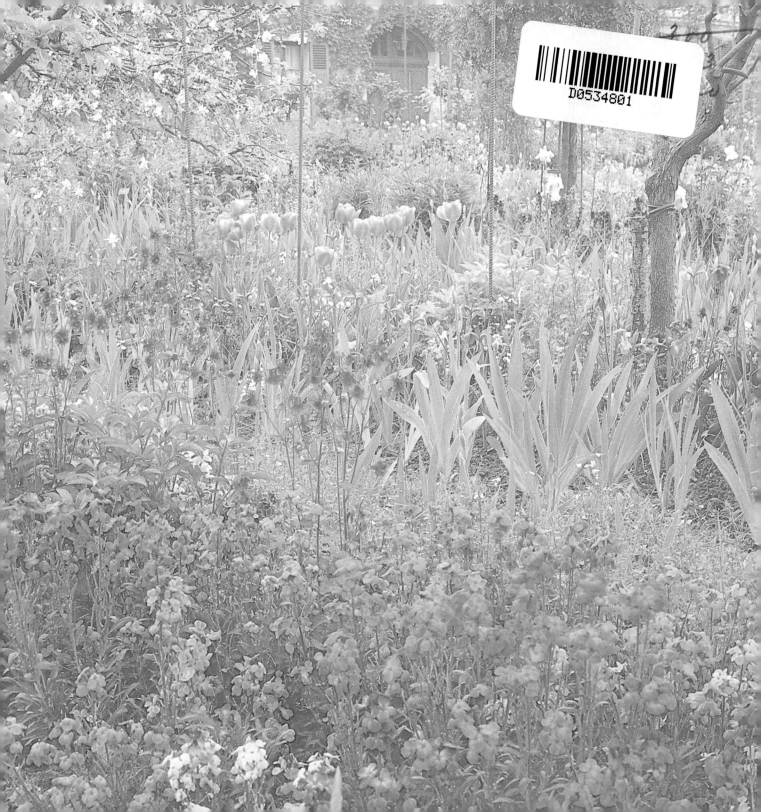

# MONET'S PASSION

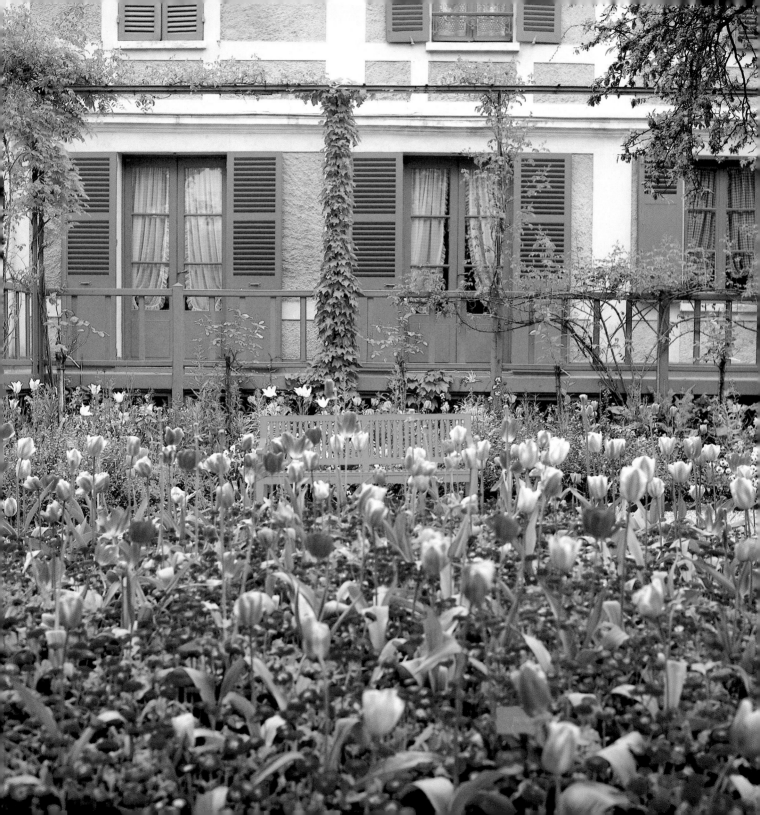

# MONET'S PASSION

IDEAS,
INSPIRATION
AND
INSIGHTS
FROM THE
PAINTER'S
GARDENS

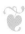

TEXT AND PHOTOGRAPHS BY
## ELIZABETH MURRAY

GARDEN DESIGNS BY ELIZABETH MURRAY
ILLUSTRATED BY HEATHER O'CONNOR

POMEGRANATE ARTBOOKS • San Francisco

Published by Pomegranate Artbooks
Box 6099, Rohnert Park, California 94927

Pomegranate Europe Ltd.
Fullbridge House, Fullbridge
Maldon, Essex CM9 7LE, England

ISBN 0-87654-443-X
Pomegranate Catalog No. A541

Library of Congress Catalog Card No. 89-61640

Designed by Bonnie Smetts Design

Printed in Hong Kong
06 05 04 03 02 01 00 99 98 97    20 19 18 17 16 15 14 13 12 11

First Edition

*To all of us striving garden artists who work with nature*
*to create gardens as our art*

# CONTENTS

# ACKNOWLEDGMENTS

viii

My thanks and appreciation to all my French friends who made my year in France not only possible but wonderful: Marcelle Boyer who first brought me to Giverny; the van der Kemps who invited me to live and work in the gardens; Monsieur Vahé, the head gardener who adjusted to a woman gardener; Mme. Claudette Lindsey, the museum director, and the staff, who welcomed me; Jean-Marie and Claire Toulgouat who shared Monet's life and enriched mine; the Andersons who lent me a car; Sabine Du Tertre who taught me about the patchwork of gardening; the Mallet family and Princess Sturdza who introduced the fine art of gardening to me.

To my dear American friends and family, thank you for your continual love, support and belief in my project. Thank you, Beth Meininger, my roommate, for putting up with my moods and mess; Jeanne Cammron, for continual inspiration as a flower artist and healer; Barbara and Steve Brooks, my adopted family, for sharing your home; Elsa Uppman Knoll, a superb garden consultant, for editing my plant lists; Joanna Reed for sharing your life as a garden artist; Kathleen Burgy, my spiritual mentor; Ellie Rilla and Kay Cline for continual loving support and enthusiasm; Lynn Turnner for helping my creative flow through acupuncture; and Marianne Gorchov for helping me focus. Thank you, Lyn Gray, Janet Ady, Janet Walsh, Michael Barnes, Debra Davalos, Natalie Lindelli, Roelof and Bernadette Wijbrandus, Yvonne Gorman and Susan Schaaf, my supportive friends. Special thanks to Heather O'Connor who took my designs and beautifully illustrated them with loving detail; and lastly, to my publishers Katie and Tom Burke who made this book possible.

# INTRODUCTION

I am a gardener, a humbling and inspirational vocation. Since early childhood, I have had a passion for flowers, nature and art. Gardening is the art that uses flowers and plants as the paint and the soil and sky as the canvas—working with nature provides the technique. A successful garden is the highest form of art, utilizing all the senses, while orchestrating plants in various color combinations, shape, height and texture in a design to convey a mood or feeling. The plants are chosen to grow and bloom together harmoniously. The garden-canvas is never static; it is constantly evolving. As seasons progress, the garden develops and reflects the garden artist's design. Claude Monet was a master gardener, horticulturist and colorist. He loved nature, flowers and light, and with each canvas he sought to capture one glorious inspirational moment. Monet's gardens in Giverny are works of art.

In the fall of 1984, I took ten weeks off as a gardener in Carmel, California, to travel through ten countries in Europe visiting gardens and museums. When I came to Giverny, I was so touched with the beauty and abundance of the flower compositions, I almost cried. I knew in my heart that I wanted to know the garden intimately, to know all the flowers in each season, to be there from spring through autumn, digging, pruning, planting, feeding, rejoicing. In short, I had fallen in love.

Determined to make my new dream come true, I set about getting in touch with M. Gerald van der Kemp, the conservator of the Musée Claude Monet. A week later, I was in his Paris office offering my professional gardening skills gratis. He was delighted, and with his wife Florence van der Kemp, he graciously offered me an apartment overlooking the garden and a food allowance in exchange for my work.

I returned to my beloved position as head gardener in Carmel and gave notice to my employers and eight crew members. I packed up my house and returned to Paris to study French eight hours a day while I lived with a French family. Two months of intensive study provided me with a very basic use of the language.

The first month at Giverny was quite challenging, proving myself to M. Vahé, the head gardener and the other seven male gardeners. None of them could understand why an American woman would want to work so hard for free in Monet's garden. But my love and enthusiasm for the garden grew as each new plant came into blossom. We gardened from 8:00 A.M. to 5:00 P.M., five days a week. I photographed and wrote before and after work each day. I met wonderful, kind, generous people in the garden. Jean-Marie Toulgouat and his wife Claire Joyes, relatives of Monet, invited me often to their charming home in the village. There I heard Monet stories, talked

about art and gardening (they are both excellent artists and gardeners) and met other fascinating people. Patricia and Ian Anderson lent me a car, which enabled me to discover the delightful Normandy countryside, and they opened up their heart and home. They live in Vétheuil, a charming village east along the Seine where Monet lived before he settled in Giverny. I met well-known gardeners like Princess Sturdza and the Mallet family, who both have exquisite tapestry gardens on the coast of Normandy near Dieppe. I befriended fellow American gardeners and artists who pilgrimaged to Giverny to paint and observe (they were all impressed with how well I spoke English!). Many museum employees and villagers invited me home for delicious French country cooking and congeniality.

Nine months later, by Halloween 1985, I packed up my treasured memories and worn gardening clothes to return to California. My life has been forever enriched. I continue to write and photograph, design gardens and flower arrangements, lecture and, occasionally, paint. In whatever I do, I try to inspire others to get to know nature and to be caretakers of our fragile and very beautiful planet. Gardening as an art form is a wonderful medium with which to begin.

*Following page:* **Claude Monet in his garden, c. 1923.** Photo courtesy of the Musée Claude Monet.

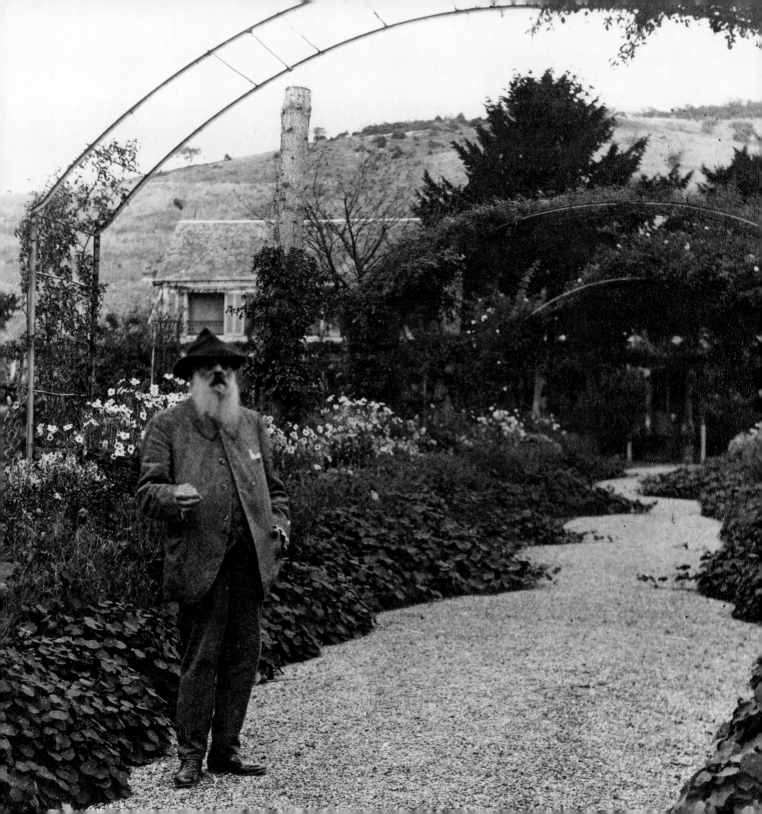

1

# THE GARDEN MONET CREATED

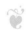

*"This is where Claude Monet lives, in this never-ending feast for the eyes. It is just the environment one would have imagined for this extraordinary poet of tender light and veiled shapes, for this man who has touched the intangible, expressed the inexpressible, and whose spell over our dreams is the dream that nature so mysteriously enfolds, the dream that so mysteriously permeates the divine light."*

Octave Mirbeau,
L'ART DANS LES DEUX MONDES,
"Claude Monet,"
March 7, 1891

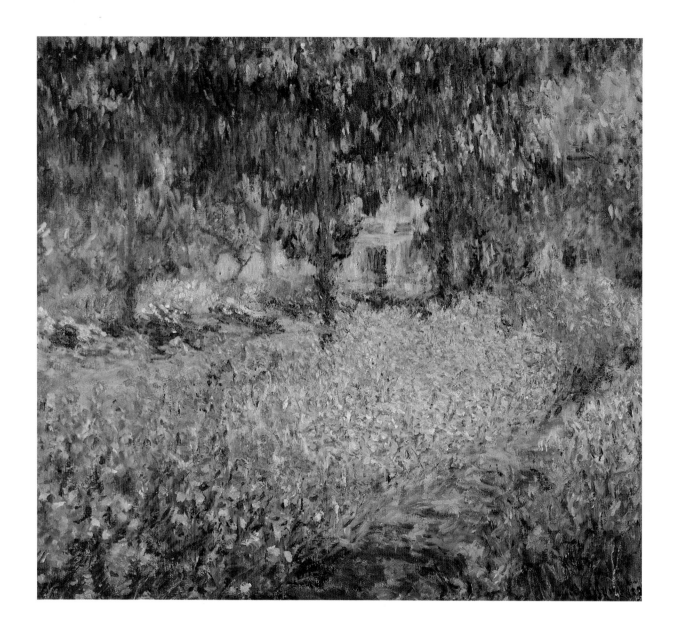

Claude Monet. *Monet's Garden at Giverny,* 1900. Oil on canvas, 31⅝ x 35⅞ in. Musée d'Orsay, Paris.

THE GARDENS AT GIVERNY consist of the Clos Normand Garden, featuring nearly three acres of flowers with the Grande Allée (the flower tunnel created with great arches of rambling roses and the broad walk carpeted with creeping, round-leafed nasturtiums), and Monet's beloved two-acre waterlily garden with the humped, green bridge woven with wisteria. We know these subjects well from Monet's paintings, brilliant, Impressionist depictions of nature's moments of full bloom, glorious color and light preserved on canvas through the hand of a great master. Each flower that grows in this magnificent painter's paradise is thoughtfully placed, just as in an exquisite flower arrangement prepared for a painter's still-life.

At the time Monet started painting, most painters began their practice with still lifes in the studio—bowls of fruit or a bouquet of flowers—and, when they could afford it, with a model. Landscape painters often sketched various views from nature and then created a pleasing composition in their studios. The *plein air* Impressionists painted directly from nature, out of doors, dedicating themselves to capturing the impression of a fleeting moment. They carried their paints, canvases and easels through the meadows and orchards and along streams until they came upon an inspirational view. Upon finding a composition and viewpoint pleasing to them, perhaps a certain group of trees back lit with the rising sun, or the reflection of a bridge or boats in a river, they set about painting it.

Monet expanded this concept of finding compositions in nature into arranging natural beauty as he designed, adjusted, redesigned and developed his gardens. He came to Giverny at the age of 43 after a series of tragic events drove him to find a place to settle. In 1877, his enthusiastic collector, Ernest Hochedé, went bankrupt and fled the country in self-exile. Hochedé's wife, Alice, and their six children were instantly poor and homeless. Their estate was sold for embarrassingly little—barely enough to pay Hochedé's enormous debts. Monet and his young wife, Camille, invited Alice Hochedé and her children to spend the summer with them in Vétheuil. During this time Camille bore their second son, Michel, and then died unexpectedly a year later from tuberculosis. Alice stayed on to help Monet care for his two young sons. Overcome with despair, burdened with financial worries and the responsibility of providing for eight children, Monet found it almost impossible to paint. He desperately sought a home for all of them where he could settle down and paint. As he was taking a local train to Paris one day he passed by Giverny and saw an empty pink house. He liked the location of the small quiet village, the light in the river valley and the one hour train ride into Paris. In 1883, Claude Monet moved his expanded family to Giverny. He was able to con-

*The Grande Allée*          Road     *Japanese Footbridge*     *Bamboo*     Mini
                                                                            Bridge   *Fields*

**Axis View of Claude Monet's Giverny Estate**
*This view of the gardens shows how Monet connected these two disjointed gardens by using a stong axis.*
*The front door of the house lines up exactly with the middle of the Grande Allée, the lower garden gate and the*
*Japanese footbridge. The length of this axis is about 440 feet from the house down the 172-foot-long allée across the road,*
*over the bridges to where the gardens end and the pastures begin.*

vince the landlord of the pink stucco house that he would pay him soon, but in the meantime he would take good care of the property.

The first thing the family did was to plant vegetables for the table and flowers for the spirit. Monet planned, planted and weeded the garden, and in the evening the children watered it, hauling buckets from the well. The old fruit orchard, overburdened with clipped boxwood that gave it the appearance of a formal, stuffy garden, was gradually transformed.

As if he were designing a flower arrangement to paint, Monet selected and placed plants in his gardens in ways pleasing to him. With such a trained eye for color relationships and the effects of light and atmosphere on color, he automatically employed the same principles he used to create his canvases. He carefully arranged pure colors in the abstract form of flowering plants to create richly patterned textures and mood by contrasting or harmonizing color relationships.

For the second half of his long, productive life, Monet was continually inspired by the ever-changing motifs in his garden. In his older age, after his waterlily pond was developed and the flower gardens had matured under his creative guidance, Monet realized he no longer had to travel searching for motifs—everything he desired was all within his gardens. His gardens became his living studio. He spent all his extra money buying extravagant plants from around the world and eventually employing six gardeners.

With the living, growing and changing plants, always subject to light and weather, Monet created an organized concentrated color environment where he could live, breathe, observe and walk, forever having his painter's eye challenged by the effects of light. The waterlily pond, the flora mirror of light, captivated him. He spent the last 20 years of his life painting that world. The gardens became Monet's passion. He considered them his greatest masterpiece.

After Monet's death on December 5, 1926, his

stepdaughter/daughter-in-law Blanche Hoschedé-Monet continued to take loving care of the gardens, house and studio—even keeping them from being occupied during the war. When Blanche died in 1947, Monet's son, Michel, oversaw the upkeep of his family home. In 1960, Michel Monet died in a car accident at the age of 82, and the entire Monet estate was deeded to France's Académie des Beaux-Arts, including the house, furniture, gardens, hundreds of Japanese woodblock prints and Monet's personal collection of 46 of his own paintings and those of his favorite fellow Impressionists. All the paintings were transferred to the Musée Marmottan in Paris and are seen by thousands of visitors annually. A new roof was put on the house, but there was very little money and not much interest in Monet's neglected country home.

In 1977, Gerald van der Kemp, curator of Versailles, was asked to be the curator of Monet's home and gardens in Giverny, and to raise funds for and oversee its restoration. Fortunately, Monsieur van der Kemp accepted this enormous task and was aided immensely by his energetic, enthusiastic American wife, Florence. Years earlier the van der Kemps had created the Versailles Foundation in New York which accepted tax-deductible contributions for the restoration and maintenance of Versailles. With presidential approval, Giverny was attached to that foundation. Americans have always loved Impressionist art, and they gave generously for the marvelous restoration of the painter's paradise.

The ambitious work began when Mrs. Lila Acheson Wallace, founder of the Reader's Digest Foundation and one of America's great benefactors for art, gardens and beauty, donated over one million dollars. Enthusiasm for the project grew as fast as the

**Claude Monet, c. 1913**
Photo courtesy of the Musée Claude Monet.

gardens did under the care of the head gardener, Monsieur Gilbert Vahé. The restoration included redigging the waterlily pond which had filled in over the years, locating a fresh water source, reconstructing an exact replica of the Japanese footbridge, reestablishing the waterlilies, irises, wisteria and roses and completely replanting the Clos Normand Flower Garden. In addition, of course, the restoration of the interiors of Monet's home and studio, including

the Japanese woodblock prints and furniture, was completed.

Much research was done to insure authenticity. Fortunately, Jean-Marie Toulgouat (Alice Hoschedé-Monet's great grandson), a wonderful painter himself, lives in the village with his wife Claire Joyes, author of *Claude Monet: Life at Giverny*. They were available to share family stories, photographs, plant lists, letters, journals and many personal memories of the Monet household and garden, aiding tremendously in the renovations.

A garden, being a living, growing creation, is never finished, it is never "perfect," and unlike a painting, a garden requires constant attention and care. Monet's paintings have survived in museums and personal collections, but his gardens have had to be re-established without the master's hand. The garden today is charming, and as with all great gardens under good care, it will only improve with time. It serves as a tremendous inspiration and provides insight into Monet's life and genius.

The Musée Claude Monet can be reached by taking the train from Paris at Gare St. Lazare (the same station Monet painted) to Vernon direction Rouen. From Vernon take a taxi, rent a bicycle or walk about two miles between the Seine River and the chalk-white cliffs edging the green meadows of Giverny. The gardens are open April 1 to October 31, Tuesday through Sunday, 10 A.M. to 6 P.M. The house is closed from noon to 2 P.M.

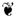

Claude Monet continually experimented with color and texture to convey the nuances of light in nature in his paintings as well as in his living canvas, his gardens in Giverny. He organized different areas of the gardens utilizing various color schemes. Monet understood fully the complexities of color, and in a sophisticated manner he sought to simplify color relationships to create a diverse, yet integrated result. In some areas he planted monochromatic masses, color zones, like the one-meter-wide flower beds of solid lavender-purple *Iris germanica*. In another area, monochromatic flowers would range in value from pure white to soft pink, vibrant red to the deepest shades of crimson, all placed together to create a tonal structure. In other places he contrasted opposite primary colors, like intense red tulips set against cool blue forget-me-nots, which seen from a distance became a violet color zone, like in a pointillist painting. Using blue with clear yellow was one of Monet's favored color combinations, and he planted reflex yellow tulips to emerge from a carpet of sky-color bluebells. (Monet even designed china in yellow, blue and white to be used for special occasions in his yellow dining room that was decorated with blue accents.) Background shades of pastel pink and green placed behind a foreground of stronger reds and greens was a color relationship Monet used not only in some of his paintings of the south of France, but also in the cool climate of his Giverny gardens. His Mediterranean-like pink stucco house had pastel green shutters, and in front of the house he planted an island bed of deep pink and red geraniums with dark green foliage, intentionally repeating the dominant house colors in the flower beds to create unity of composition.

Unfortunately, any specific garden notes Monet may have written about his color themes and specific planting plans have been lost, but by studying

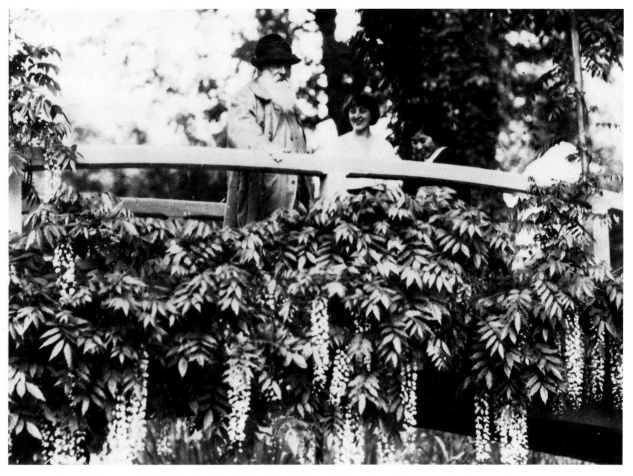

**Claude Monet with Lily Butler, Mrs. Kuroki and Blanche Hoschedé-Monet on the Japanese bridge, 1921.**
Photo courtesy of the Musée Claude Monet.

Monet's use of color in his paintings, how he created illusions of atmospheric conditions, movements of light, distance, texture, shapes and color zones, we can see how he employed these lessons in his gardens. Fortunately, Monet's gardens were well documented by many different photographers at the time, including himself. We also have for historical reference the paintings Monet did of his gardens, articles written about his gardens and letters he wrote commenting on his gardens, the source of his greatest pleasure.

Monet did not like plants with variegated foliage in his gardens. He found them too busy and was bothered by their hybridized look. He did, however,

use bicolor flowers, like burgundy cactus dahlias with gold-tipped petals and pale cream peonies tinged with pink in the center, to introduce varied nuances of color in an otherwise monochromatic flower bed. Monet used these prized flowers with disciplined discretion, placing them with a deliberation equal to that required to place a brush stroke loaded with two colors. He generally preferred the simple, single-petaled flowers to the more hybridized fancy doubles. He enjoyed incorporating wild native plants into his garden, such as the local wild scarlet poppies and the handsome mullein (*Verbascum*) with its downy grey-green leaves and tall flower spikes in soft yellow or purple. Monet found native plants did well with little care and would re-seed themselves and return each year. He also liked their natural, indigenous look. Monet continually experimented with new seeds, bulbs and plants and ordered exotic plants from all over the world, including his prized lilies and peonies from Japan. His son Michel and stepson, Jean-Pierre Hoschedé, hybridized their own poppy, an exceptionally large clear red flower created from combining a wild strain with a garden variety, which they named "Monet."

Before introducing a new plant unfamiliar to the garden, Monet grew it first in his side nursery garden by the greenhouse and cold frames. Upon seeing it in bloom and learning more about its particular cultural requirements, he could determine if the plant was suitable for his garden and if so, exactly where it would be of the greatest value.

To break uniformity and unite the whole garden composition, Monet chose a dominant color that he would interweave throughout the garden. Sequences of small touches of blue, lavender or gold accents would be interknit within the flower scheme. Color sequences varied with the progression of each season accentuating the changes in light and weather. The interplay of delicate to strong color contrasts keynoted the floral compositions of the Clos Normand Flower Garden, breaking the uniformity of the garden grid. The abundance of sprawling edging plants like aubrieta, saxifraga and nasturtium softened the straight lines of the grid-like layout. Monet understood that a structural garden plan was essential for such a complicated color palette of lavish, creeping plants. If the layout had been all abstract, rounded shapes, the result would have been very confusing and unsatisfying.

To increase the various atmospheric effects on the garden, Monet planted rich orange, pink, gold and bronze wallflowers and tulips together on the west side of the flower garden to emphasize the effects of the setting sun. He used clear blue and delicate salmon hues elsewhere to convey the tonal feeling of mist softening the morning light. His pastel hues planted in the distance next to bright, crisper values of the same color in the foreground added a painterly illusion of distance in the mist.

Luminosity was as important in Monet's gardens as it was in his paintings. He was as keenly observant of the effects of light shining through the petals of an iris or poppy and the reflections of the sky and surrounding landscape in his waterlily pond as he was of the light illuminating the textures of a building, as he depicted in his series of paintings of the Rouen cathedral. He observed through the vistas he cut into his bamboo grove how light and shadow patterns played together, adding animation to the garden. Monet understood the magical ability of light to soften or dazzle color. He used subtle hue changes in the shades of the green foliages he combined to

create even more contrast between light and shadowed foliage. From the spring hues of yellow-green willow leaves and a bright grass-green lawn to the crisp, dark hollies and soft blue-green iris foliage, he blended leaf shape, texture, size and surface sheen to enhance the effects of light.

Forms were suggested by contrasts and relationships of colors in both Monet's paintings and his gardens. He learned valuable lessons about using pure color *(tons clairs)* and the juxtaposition of shapes from Japanese woodblock prints, as did many of his fellow Impressionists. His immense collection of Japanese woodblock prints, hung all over his house, continually inspired him. Just as he experimented on his canvases, trying to capture the light and reflection of a moment, Monet used his gardens to try out his color ideas. In his gardens he could organize nature into variations and contrasts of color. The multiple small, rectangular flower beds were organized like swatches of paint on the master's palette. With flowering plants, he contrasted complementary or near-complementary colors and then varied them into closely related tints of color.

The arched Japanese-style footbridge created an elliptic reflection in the waterlily pond and was the main accent of the water garden. In designing his waterlily garden, Monet organized the aspects of nature that most intrigued him. The pond was a mirror reflecting each nuance of atmospheric change — a moving cloud, a ripple of wind, a coming storm. It held inverted images of the surrounding landscape

*Text continues on page 16*

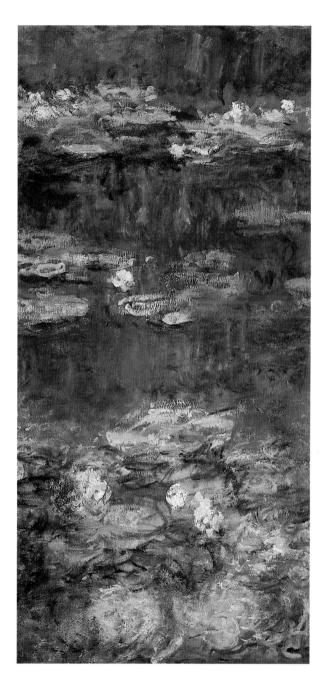

Claude Monet. *Green Reflections* (detail), 1914-1922. Oil on canvas, 77½ x 333½ in. One of eight compositions comprising *Waterlilies. Study of Water.* First Waterlilies Room, Musée de l'Orangerie, Paris. Claude Monet donation, 1922.

9

# THE
# CLOS NORMAND
# FLOWER GARDEN

10      Garden Dimensions
        380 feet x 240 feet

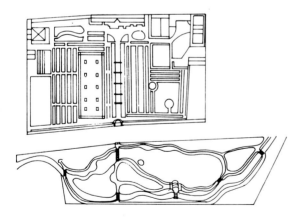

Plan showing the relationship of the
Clos Normand Flower Garden and the Water Garden

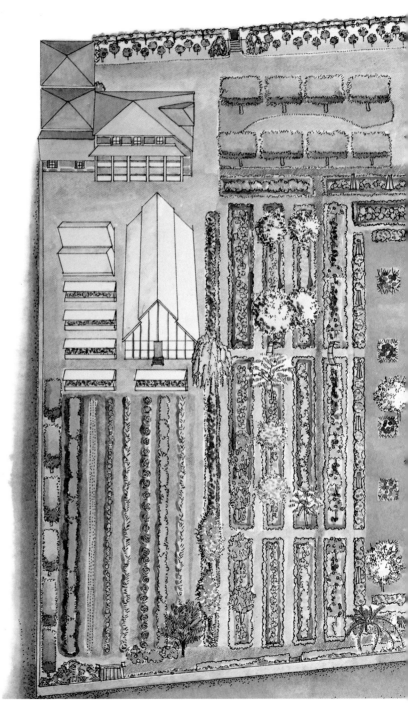

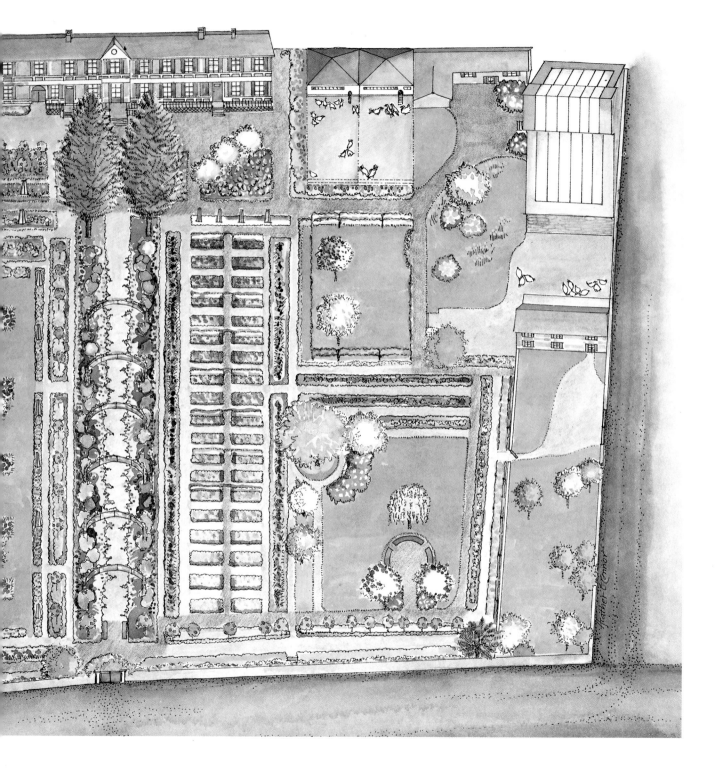

# THE WATER GARDEN

12    Garden Dimensions
      418 feet x 153 feet

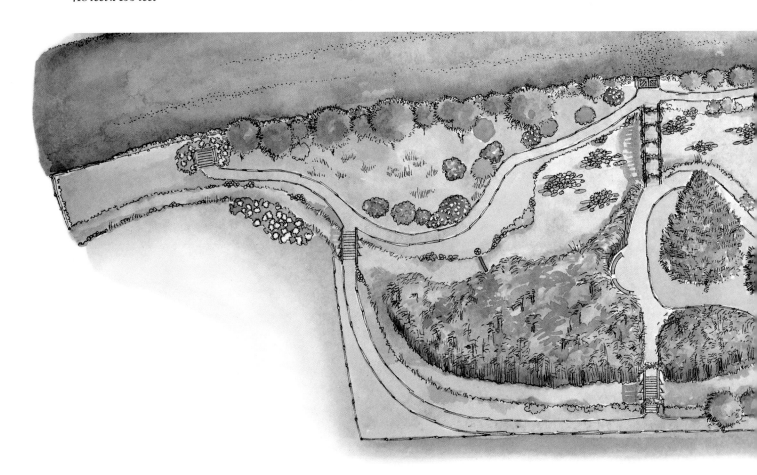

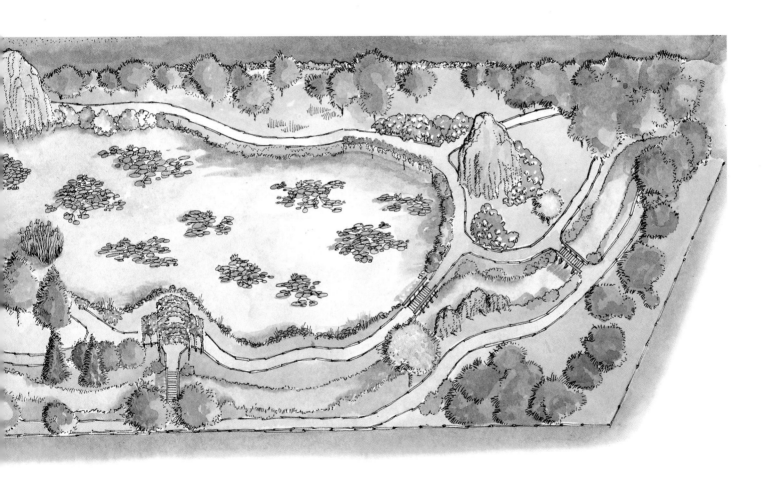

THE GARDEN MONET CREATED

## THE CLOS NORMAND FLOWER GARDEN

1 rose trees and espaliered pears along the wall, gate to road

2 Monet's second studio

3 greenhouse for orchids

4 cold frames for seedlings

5 growing fields for new plants

6 steps to underground passage leading to waterlily pond

7 linden trees where Monet's family picnicked

8 spring planting of wallflowers under apple, cherry and plum trees

9 lilac trees

10 cherry trees

11 shrub and pillar roses on 10-foot columns

12 perennial border with iris and roses

13 tamarix tree

14 island bed with rose trees, cottage pinks and tulips with forget-me-nots

15 pillar roses with monochromatic flowers

16 lawn with plantings of iris and oriental poppies

17 Monet's house — 104 feet long by 20 feet deep

18 spruce trees

19 the Grande Allée (172 feet long by 22 feet wide between arches)

20 the gate Monet crossed to go to the Japanese footbridge

21 Japanese flowering crab apples underplanted with yellow wallflowers in spring

22 "paint box" flower beds (6 feet by 13 feet)

23 clematis arbors over flower beds

24 white turkey yard

25 espaliered apple trees around lawn

26 monochrome perennial beds

27 smoke tree

28 perennial beds

29 standard roses

30 entrance building for visitors

31 Monet's third studio — (Atelier aux Nymphéas)

32 chicken yard

33 private residence

34 espaliered apple trees

35 pine tree

36 green benches

37 path where visitors can walk (indicated by darker color in illustration)

## THE WATER GARDEN

1 steps to underground passage leading to flower garden

2 small bridge over the Rû that leads to the back of the garden

3 bamboo grove

4 water gate where pond water can be let out

5 the gate Monet crossed to get to the Grande Allée

6 the Japanese footbridge with wisteria arbor (18-foot span)

7 round stone benches

8 copper beech tree

9 small bridge with rose arch

10 old weeping willow tree

11 yellow water irises (12 x 12 ft. island planting)

12 waterlilies

13 azaleas

14 rose arches over a bench; boat dock area

15 small bridge

16 wisteria arbor (6 feet high; 34½ feet long)

17 bridge over water gate where fresh water is allowed in

18 Japanese cherry tree

19 weeping willow tree

20 bridge

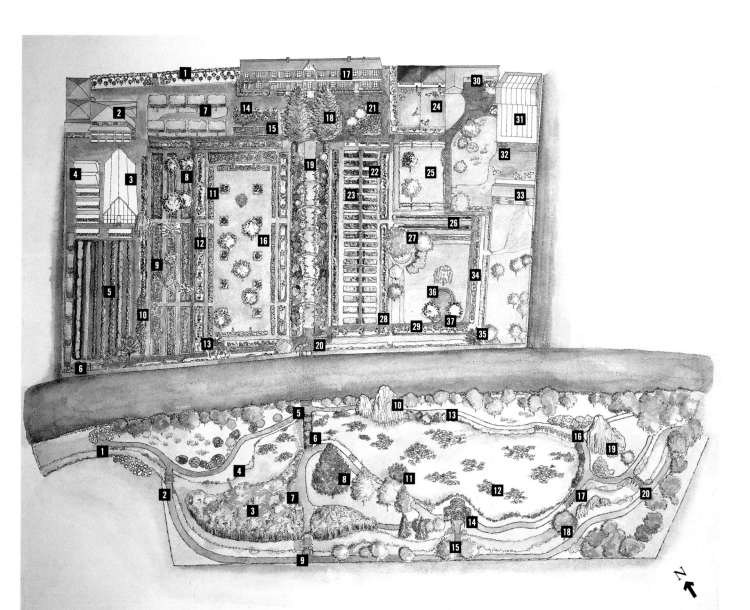

while simultaneously supporting thousands of floating water flowers. The effect was that of a prism in the light spreading shimmering shades of precious gold, ruby, amethyst, sapphire and topaz over the water surface. These waterflowers were like multifaceted jewels on deep green settings of round, floating pallet-shaped leaves. The moving images of light and reflection flickered and changed around them, but they, too, were subjects of the light. Light regulated their morning opening and evening closure and added extra sparkle to these gems when water droplets caught the passing sun.

In spring, the gardens were riotous with luxuriant color. There were actually two springs: St. Valentine's Day was occasionally greeted with precocious little white snow drops, purple and gold crocuses and masses of bluebells. Later, the 'poet's narcissus' with stark white petals and a red-rimmed golden cup bloomed in naturalized drifts throughout the lawns. Bright yellow winter jasmine cheered up corners of the flower garden and was cut along with the golden 'emperor' daffodil (like 'King Alfred' daffodils) for sunny indoor arrangements. Dutch tulips proceeded in striking colors. Darwin tulips in shades from white to black and every color but blue bloomed on 2½-foot stems. Parrot tulips were planted for their unusual fringed petals and twisted shapes. Retroflex tulips in clear yellow that look much like lilies grew alongside blue bells or blue forget-me-nots. Rembrandt tulips (popular subjects in 17th century Dutch flower paintings) with their striped and mottled petals in contrasting colors, like yellow and red, were used as brilliant color spots in the early spring.

Later, pansies with little faces and long-lived English primroses, sweet-scented wallflowers, crown-like columbine and spice-scented stock all bloomed

in great masses of molten colors within lavender frames of aubrieta. Unhybridized *Clematis montana*, with its profuse sprays of white flowers blushed with rose or azure, were trained to hang in loose, casual garlands from light structures that outlined the sky. The lacy flowers were left to blow freely in the wind across the garden path, thereby uniting the many small multicolored paintbox-like flower beds below.

Monet coordinated floral compositions to complement the blooming of the pink or white blossoms of apple, cherry and plum trees. Golden chain trees, standard wisteria and lilacs were sprinkled liberally to add their delightful fragrances and regal colors to the garden horizon.

By May and June there was no holding back the rampage of late spring color. The mauve bearded iris (*Iris germanica*) bloomed in three-foot-wide beds of solid violet. Huge crinkled Oriental poppies in colors of bright vermilion or soft coral pink and dusty mauve, characterized by large velvety black splotches in their centers, bloomed profusely in splashy clumps throughout the lawns.

Tree and herbaceous peonies were mainstays in the large, mixed perennial borders and along the banks of the waterlily pond. With both varieties, Monet preferred the less common, single flowered Japanese type with flowers ten to twelve inches across. The silky colors ranged from pure white to creamy yellow, pink and red, with the tree peonies adding shades of lavender and purple.

About the time the peonies, irises, and Oriental poppies were in their full glory, the roses began to bloom. Monet had hundreds of magnificent roses in a myriad of colors and forms. Pink standard roses bloomed in the island beds near his house. Iron arches covered with climbing roses distinguished the

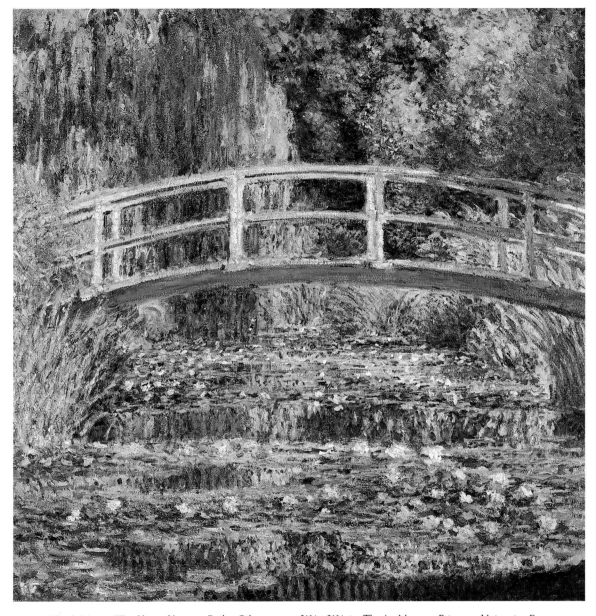

Claude Monet. *Waterlilies and Japanese Bridge.* Oil on canvas, 31⅝ x 31 5/16 in. The Art Museum, Princeton University. From the collection of William Church Osborn, Class of 1883, Trustee of Princeton University (1914-1951), President of the Metropolitan Museum of Art (1941-1947); gift of his family.

THE GARDEN MONET CREATED

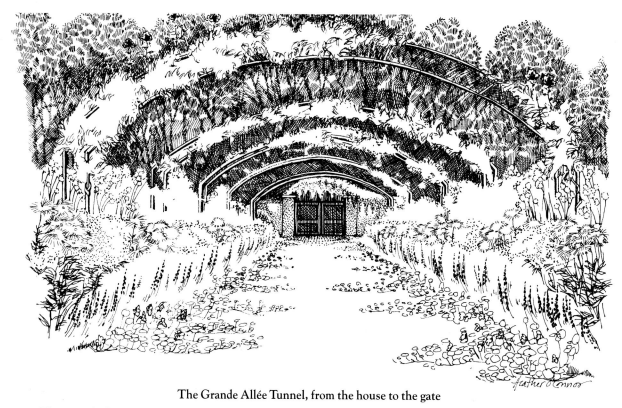

The Grande Allée Tunnel, from the house to the gate

*The tunnel effect Monet achieved with the Grande Allée rose arches and creeping nasturtiums was even more exaggerated by the slight downhill slope from his house to the gate. The walk is 10 feet wide with a 22-foot span between the 13-foot-high arches. The flower beds are 7 feet wide and mounded 24 inches high.*

main walk, creating the Grande Allée. Six- to eight-foot-high pillar roses and roses trained on six-foot-tall umbrella-like supports all added structure and height to the garden. Old-fashioned shrub roses with their heavenly scent, rich colors and deep green foliage were planted in solid masses between the pillar roses to frame a lawn and provide the background for the richly colored perennial flower borders. The climbing rose *la belle Vichyssoise,* which grows 21 to 24 feet high with long clusters of small, very scented blossoms, grew up existing tree trunks and over trellises along the pond, where they added to the spontaneous mingle of textures and blossoms.

Below his second-story bedroom window on a 20-foot-long trellis, Monet grew his favorite rose, the 'mermaid', which boasted clear yellow, single flowers and a deep gold center of delicate stamens. Monet always preferred single roses (like all flowers), and he liked to combine pink, yellow and salmon roses together, or red and pink for a monochromatic blend.

The Grande Allée Tunnel, from the gate to the house

*The house is perfectly framed with the series of arches and the curved pruning of the spruce trees. This is the view that greeted Monet's visitors on their return from the waterlily garden.*

As spring matured into summer thousands of flowers of one variety might bloom at once creating a "color zone" of white, pink, rose or lavender penstemon *(P. gloxinioides)* or stock *(Matthiola)* three feet high. Later, *Phlox paniculata* added red, reaching three to five feet in height. Hollyhocks *(Alcea rosa)* in soft pastels, foxgloves *(Digitalis)* in deep rich mauves and purples and delphinium in every shade of blue from baby blue to deep midnight would shoot spires of color eight feet into the sky. Straight lines of color created a rhythmic movement and spatial variety among the borders. Free-flowering old fashioned cottage "pinks" *(Dianthus plumarius)* edged beds with sprawling informality and a spice fragrance. Flame-colored nasturtiums *(Tropaeolum majus)* with round, yellow-green leaves crept along the Grande Allée etching a zigzag walking path as they completed the tunnel effect begun with the rose arches above. Cactus dahlias with their fluted petals, sometimes edged in gold with deep crimson centers or

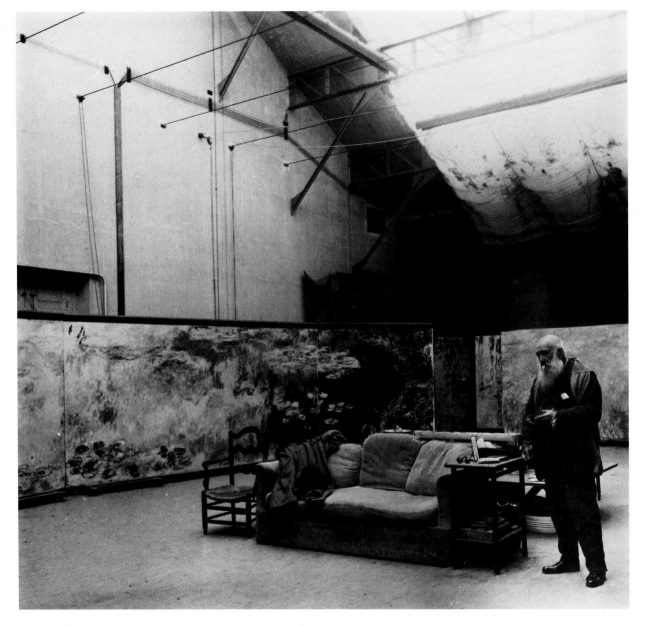

**Claude Monet posing in front of his huge waterlily paintings in his third and final studio at Giverny, c. 1922**
Photo courtesy of the Musée Claude Monet.

THE GARDEN MONET CREATED

delicate lavender, bloomed in every bright color and subtle shade available in wide beds. (Monet always purchased the latest varieties of seed available from Etoile de Digoin, a leading dahlia breeder.)

By September gold and shades of lavender and purple dominated the rampantly growing garden. Sunflowers with their huge heads, always facing the sun, were like animated scarecrows turned into flowers. Golden rod, with its fuzzy soft heads, and *Helianthus,* the gold daisy-like sunflower, produced thousands of flowers in five-foot-tall masses, dominating the fall color scheme. White Japanese anemones (*Anemone elegans*) and single old-fashioned gladioli took over beds in wild, elegant abandon. Snapdragons and china asters were perfect for cutting and grew in an orderly profusion of pastel rainbows. Large swatches of rich blues, purples, violets and deep, ruby pinks provided by the invaluable perennial asters (*A. frikartii* and *A. novi-belgii*) were woven through the golden tones, completing the lavish autumn tapestry.

Monet's garden was never designed for any particular winter interest with spectacular berries, grasses or tree bark. He often traveled in winter to paint in different locations such as Venice, southern France, London or Norway, but sometimes the local winter-scapes would captivate his interest. When the Seine froze over and huge blocks of salmon and blue ice floated over its silver surface, Monet painted furiously in the freezing cold along the river bank. He respected each season and its particular shifting light and atmospheric changes. When he craved flowers in wintertime, he visited his greenhouse to enjoy the orchids he cultivated there.

Monet's gardens serve to teach us that in gardening we have an opportunity to work with natural elements in an artistic, organized manner. We can choose to saturate an area with color and texture, or emphasize the play of light and different shapes to form harmony or contrast. Just as a successful landscape painting uses an organization of colors to give an illusion of a three-dimensional reality, so does artistic garden design employ specific shapes and placement of color to create depth, exaggerate light and shadow, and bring into being the inner vision of its creator.

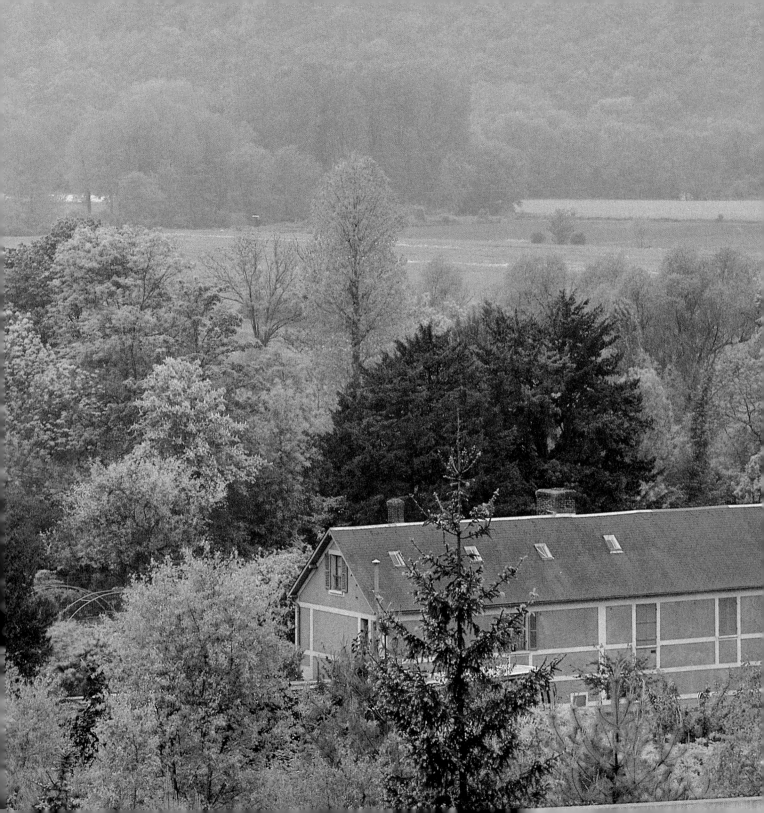

# 2

# MONET'S GARDEN TODAY

"If, I can someday see M. Claude Monet's garden, I feel sure that I shall see something that is not so much a garden of flowers as of colors and tones, less an old-fashioned flower garden than a color garden, so to speak, one that achieves an effect not entirely nature's, because it was planted so that only the flowers with matching colors will bloom at the same time, harmonized in an infinite stretch of blue or pink."

Marcel Proust,
LE FIGARO,
"Splendors,"
June 15, 1907

24    *Previous page:*

Monet's charming house of crushed pink brick is nestled quietly among tranquil green textures of trees. The river valley spreads beyond his garden boundaries to the lush farmlands, picturesque meadows and the shimmering light along the Seine River. This is the countryside that enchanted Monet, where he traveled in a little studio boat to capture on canvas the fleeting mist at sunrise along the riverbank or a red field of dazzling poppies on the hillside. He never tired of the magic and mystery of light and the effects mist, snow, sun and clouds had on his beloved motifs nature provided.

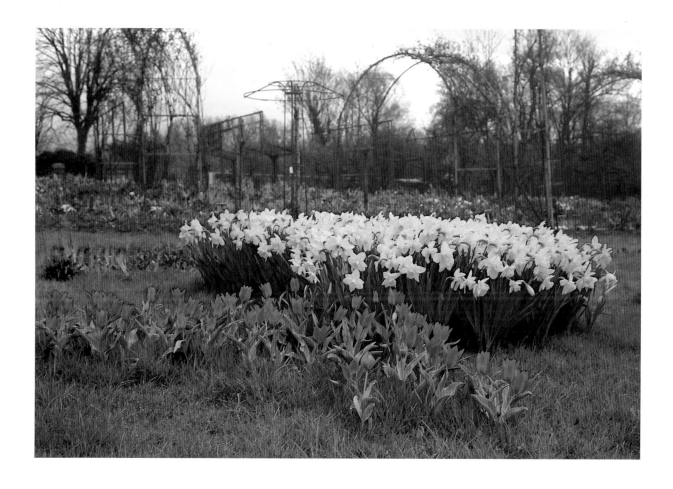

Monet used thousands of Dutch bulbs in his garden to provide him with early spring color in every shade he desired. Bulbs are the harbingers of spring, blossoming before the first green leaves bud from dormant trees and shrubs. The iron rose supports are silhouetted against a grey sky in early spring, creating a dramatic contrast, with the striking red tulips set against a drift of sunny yellow daffodils. These bulbs have been naturalized in the lawn. In the autumn, after cutting and pulling back the sod like a laid carpet, the gardeners plant the bulbs with bone meal and then replace the sod over the planted bulbs. After blooming, the lawn will be mowed around the tulip and daffodil foliage until it yellows.

MONET'S GARDEN TODAY

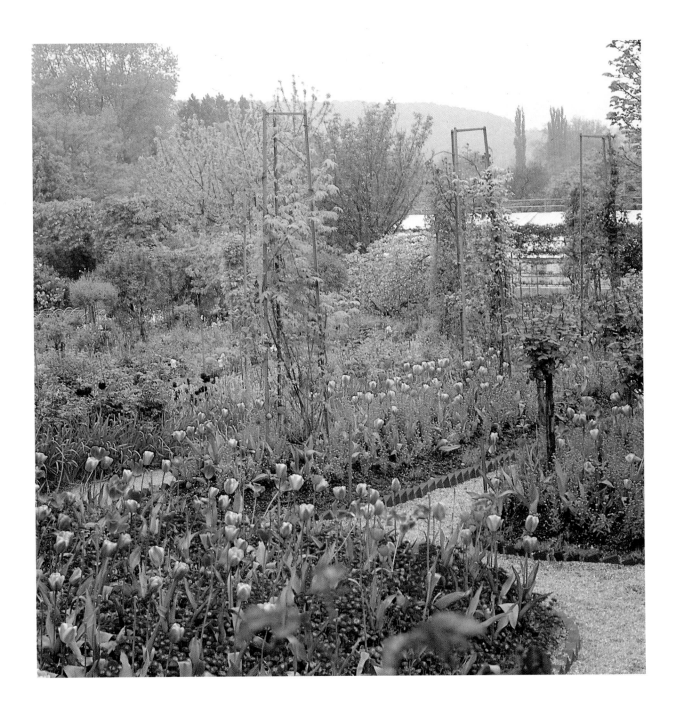

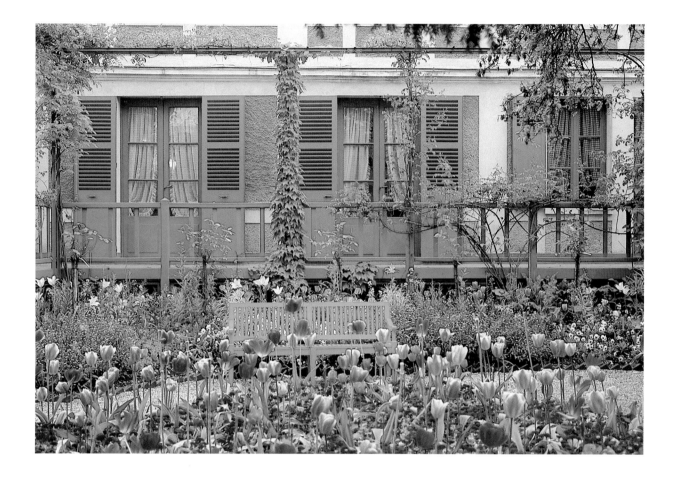

A monochromatic island flower bed is planted in front of Monet's house echoing the same color schemes of his house in pinks and greens. A soft pink tulip edged in white is planted with a deeper rose pink tulip. Early and late varieties of tulips in the same color shades are interplanted together to extend the blooming season by several weeks. The overplanting is pink, rose and red English daisies *(Bellis perennis)* which are perennials often used as annuals. For summer and autumn the tulips will be replaced with monochrome geraniums *(Pelargonium hortorum)* in pink and red tones with deep green, velvety, round leaves. When viewing the house from the garden these flower beds are in the foreground. It was Monet's idea to use deeper, more vibrant tones of color in the foreground and repeat the same monochrome colors in the background in softer tones. This repetition of color integrates the house into the garden, creating a marvelous whole look with utter simplicity. This is one of many painterly techniques Monet used in his garden.

MONET'S GARDEN TODAY

28

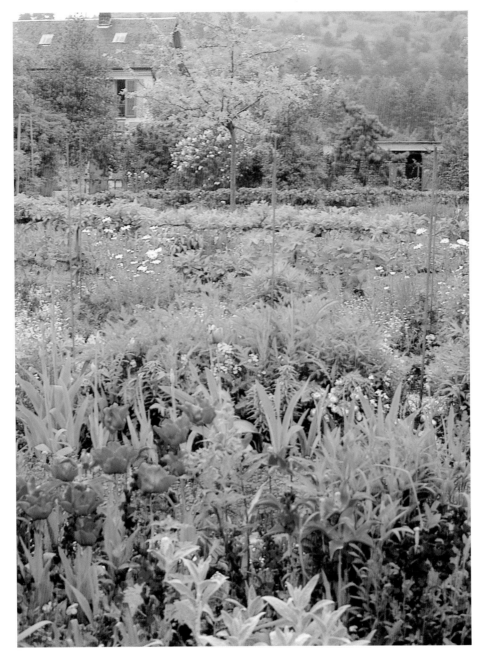

By early May the garden is a rich tapestry of green accentuated with thoughtfully placed flowering plants. An informal double border of mauve tulips ('May time' and 'blue parrot') with deep burgundy velvet wallflowers (*Cheiranthus cheiri*) contrast beautifully with the silver downy leaves of lamb's ears *(Stachys byzantina)*. Lavender aubrieta *(A. deltoidea)* gracefully edges the borders, a plant Monet used extensively to soften and unify beds with its spreading, low, grey-green foliage and rose, lilac or purple flowers.

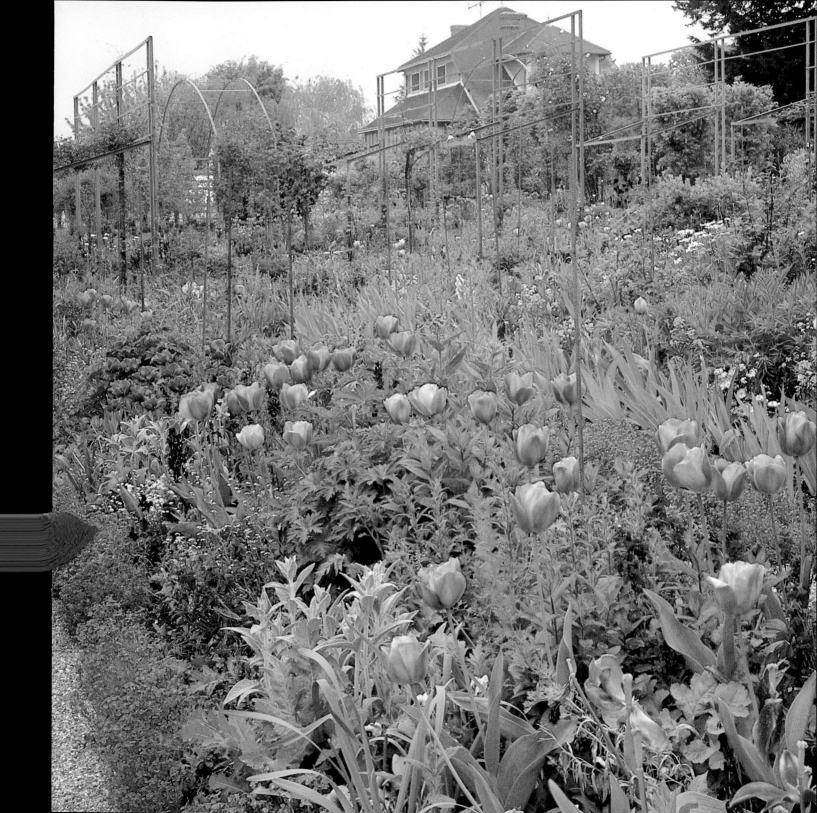

30

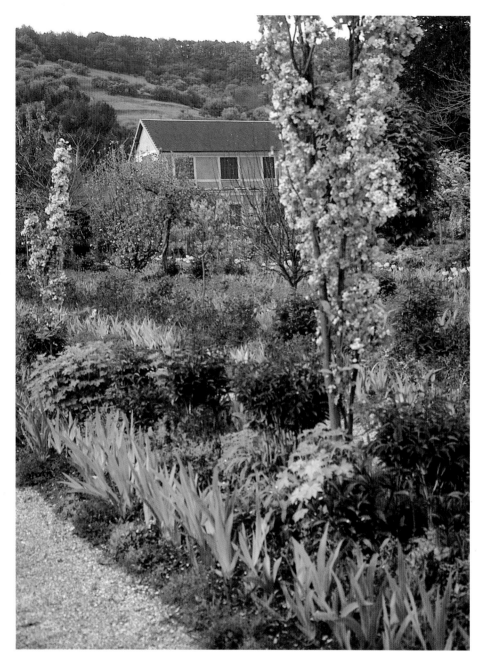

Ribbons of color and texture are woven into the early spring perennial borders. Soft, rounded, violet aubrieta cushion the blades of iris spears, while dark green peony foliage outlines rust wallflowers set against blue forget-me-nots exaggerating the distance. The vertical columns of the Japanese flowering cherry (*Prunus serrulata*, 'Beni Hoshi') echo the soft pink colors of the house.

A refreshing white color theme is used in spring to rest the eye in a quiet part of the garden. White narcissus are planted under the snowy blossoms of a fruiting plum tree. These flower borders will completely change to rich golds, oranges and deep reds by summer to complement the burgundy plum foliage.

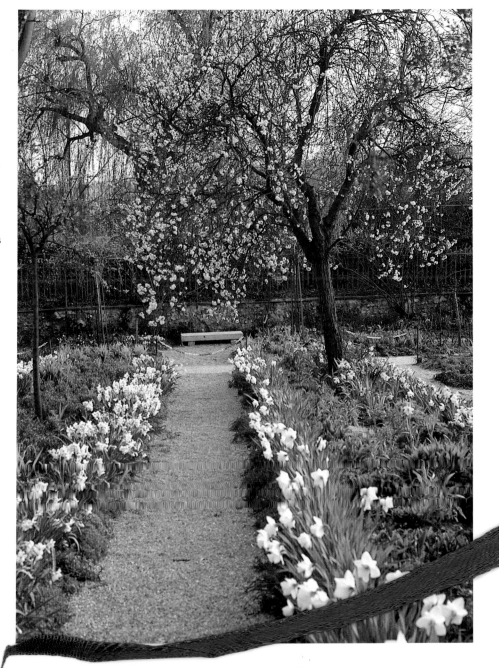

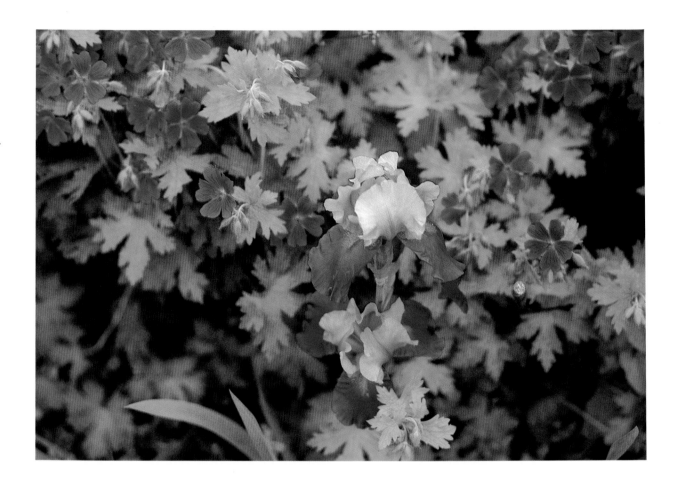

Cranesbill, the perennial geranium, combines beautifully with a purple and gold bearded iris. The sword-like foliage of the iris pierces through the finely cut geranium leaves dotted with the purple-veined lilac flowers. Monet enjoyed growing rare and unusual kinds of iris, like these bicolor varieties, to use sparingly as accents.

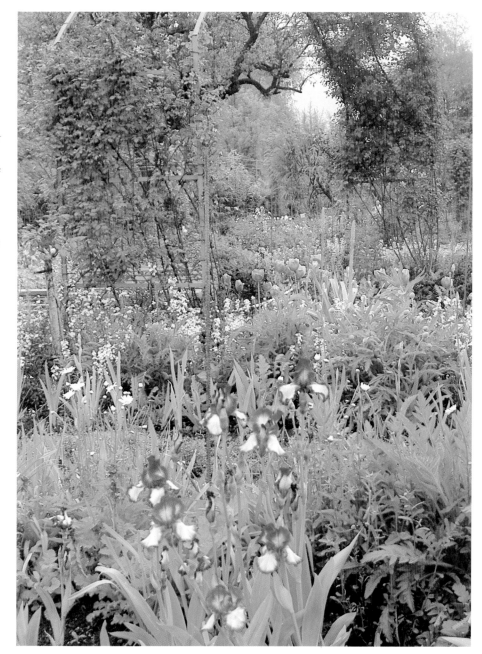

MONET'S GARDEN TODAY

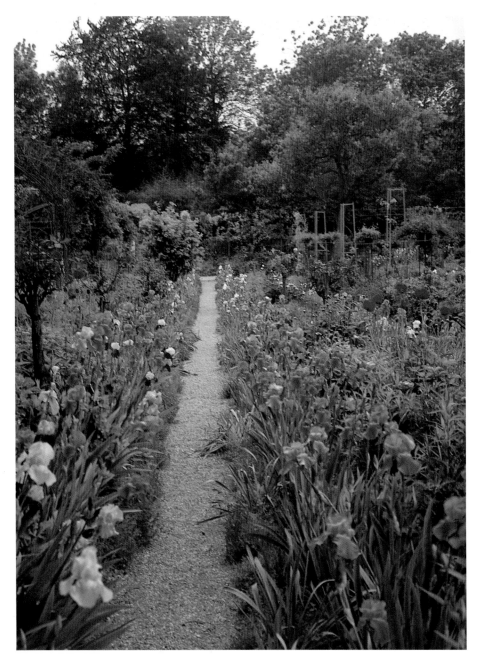

The majority of the bearded iris Monet grew were *Iris germanica,* an old-fashioned, very fragrant, lavender-purple iris. He grew them in solid purple color zones, beds three to five feet wide and up to 100 feet long. Bright vermilion red Oriental poppies *(Papaver orientale)* with striking velvet black centers accent the iris beds today like flaming red torches.

MONET'S GARDEN TODAY

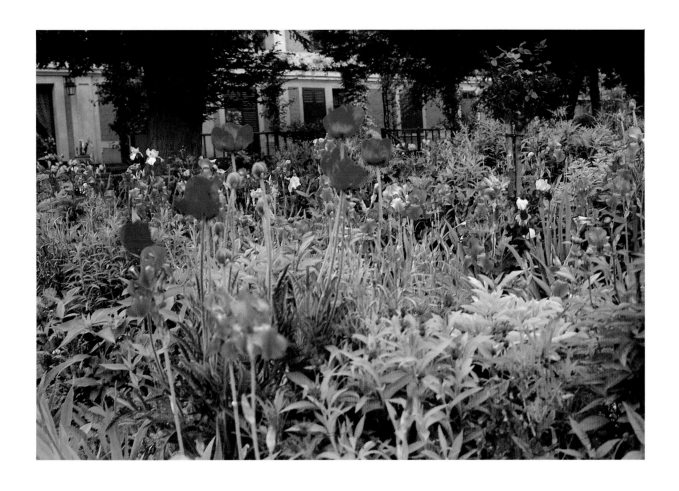

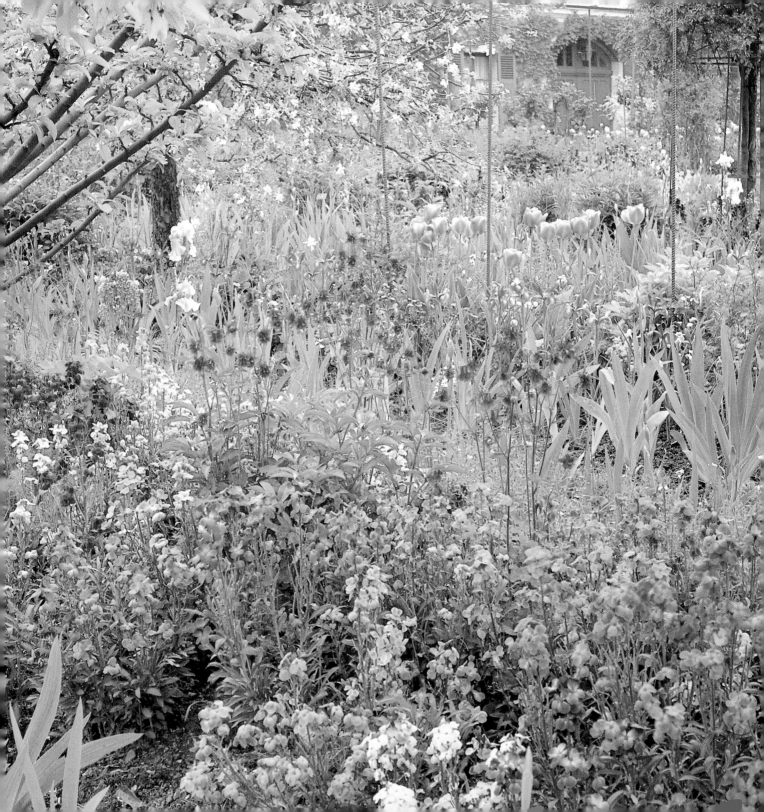

On the west side of the garden fiery orange, gold, bronze and copper English wallflowers are planted en masse with red columbine *(Aquilegia vulgaris)* as ruby accents with the cool blue Dutch iris. These colors glisten and glow, warming up the spring garden all day. The most stunning effect occurs at sunset when the red light emphasizes and accentuates the molten fire flower colors. This planting illustrates one of the many subtle color schemes Monet used to highlight natural atmospheric light changes.

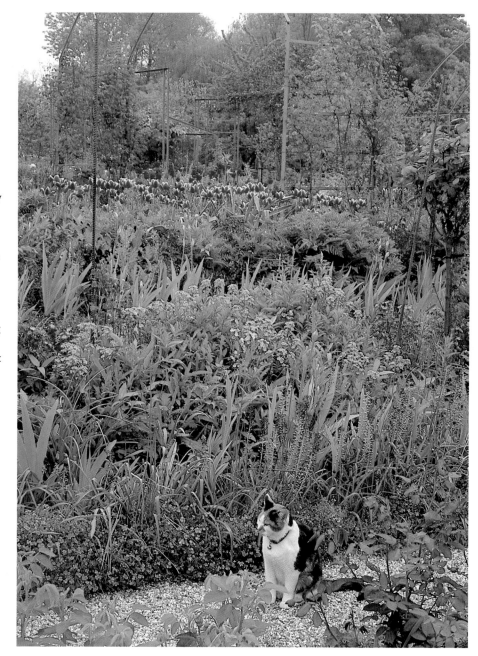

MONET'S GARDEN TODAY

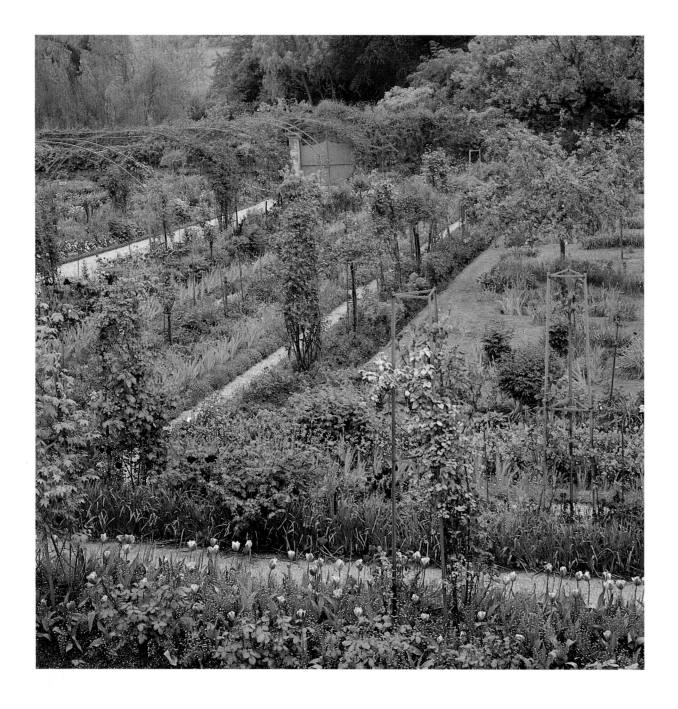

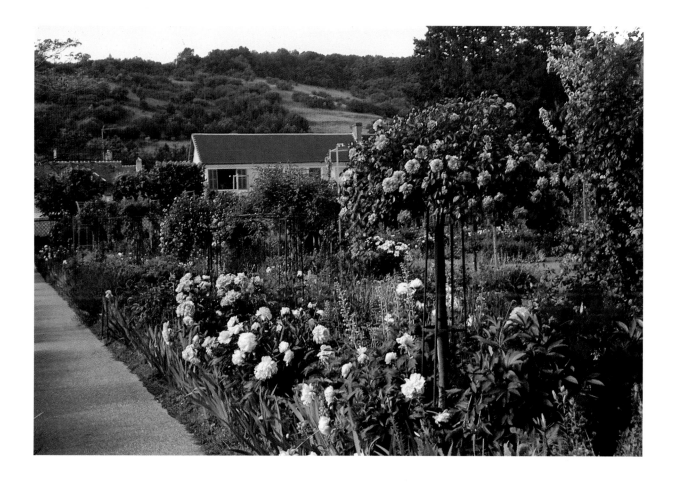

There is still much orderliness in the garden in early spring before the flowers have completely taken over the neat gridlike paths. By late May and early June the iris have faded to make way for the outburst of roses and peonies. The romantically voluptuous flowers bloom together in a monochromatic bed of whites, pinks and reds. Walking past, one is embraced with heavenly scents and the luxurious abundance of spring.

MONET'S GARDEN TODAY

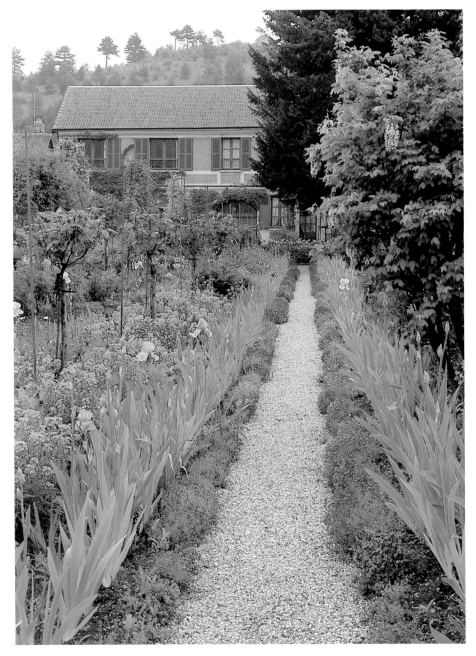

Many people wonder when is the best time of the year to visit Monet's garden. The gardens of spring and summer/autumn are entirely different. The spring garden is the essence of freshness and clarity of pure color on an organized geometric layout. As summer matures to autumn, the garden's abundance ripens in full. The garden flourishes, at its peak of vigor and bounty.

MONET'S GARDEN TODAY

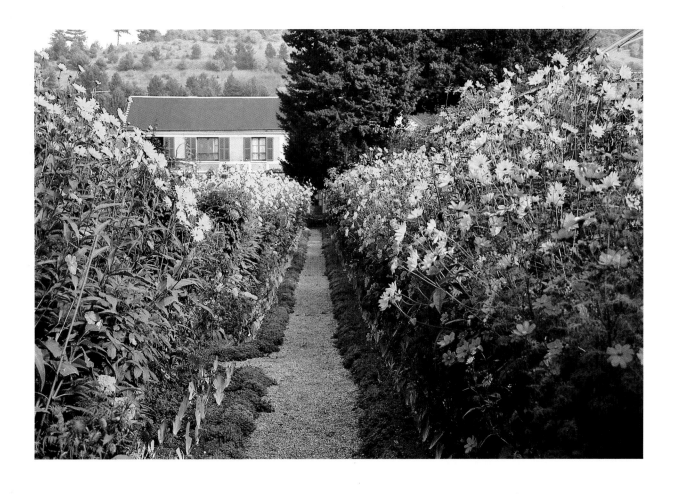

Dwarf apple trees have been trained so their branches grow along horizontal wires framing a lawn. Espaliered trees require careful pruning, but fall production yields are high in very little space.

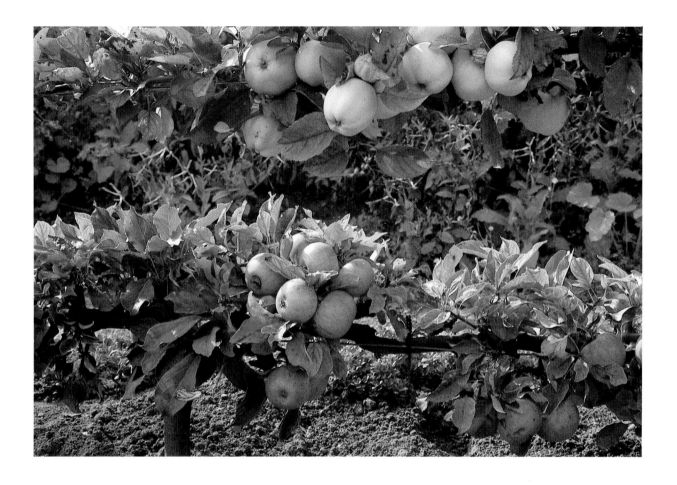

Normandy is known for its apples, and an "apple fence" is a charming and fruitful way to create a light open boundary in the garden. Pink nicotiana blooms beyond the ripe apples.

44 Rich mauves to blue-violet and rose are embroidered into the garden tapestry in autumn with perennial asters or Michaelmas daisies. These many species of spectacular lilac flowered plants *(A. frikartii, A. novae-anglia* and A. *novi-belgii)* grow three to four feet tall and usually require staking. *Aster frikartii* is native to the Himalayas and begins its abundant bloom of single daisy-like flowers in May and continues to October. Many rich color blends of white, cream, pink, rose, lavender, purple and blue are available with perennial asters. They are an essential plant to use for weaving an autumn garden tapestry.

Normandy is known for its apples, and an "apple fence" is a charming and fruitful way to create a light open boundary in the garden. Pink nicotiana blooms beyond the ripe apples.

44 Rich mauves to blue-violet
and rose are embroidered
into the garden tapestry
in autumn with perennial
asters or Michaelmas dai-
sies. These many species of
spectacular lilac flowered
plants (A. frikartii, A.
novae-anglia and A. novi-
belgii) grow three to four
feet tall and usually require
staking. Aster frikartii is
native to the Himalayas

bloom of single daisy-like
flowers in May and contin-
ues to October. Many rich
color blends of white,
cream, pink, rose, lavender,
purple and blue are avail-
able with perennial asters.
They are an essential
plant to use for weaving an
autumn garden tapestry.

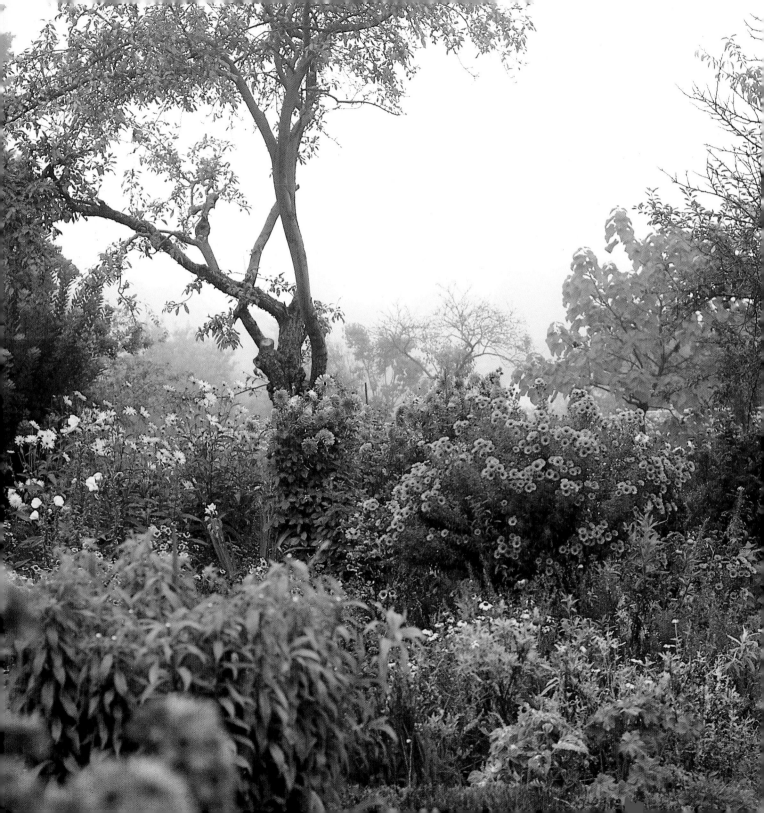

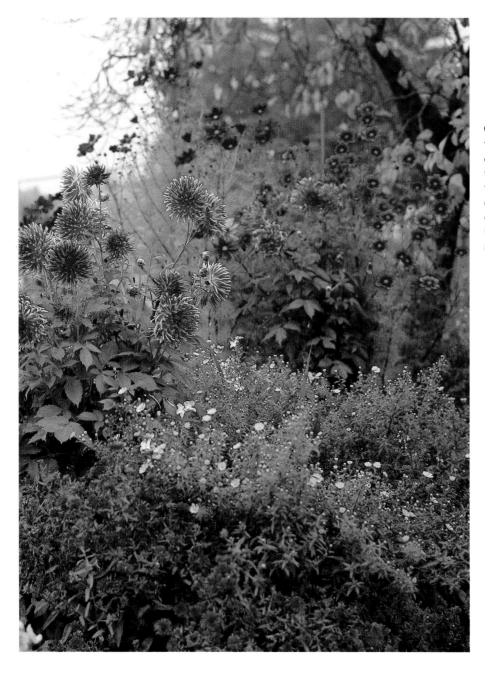

Coral dahlias edged in pale yellow blend with hot pink cosmos *(C. bipinnatus)* towering over the light airy white rose asters. This essentially monochrome color scheme is further uni-fied with deep greens and soft morning mist.

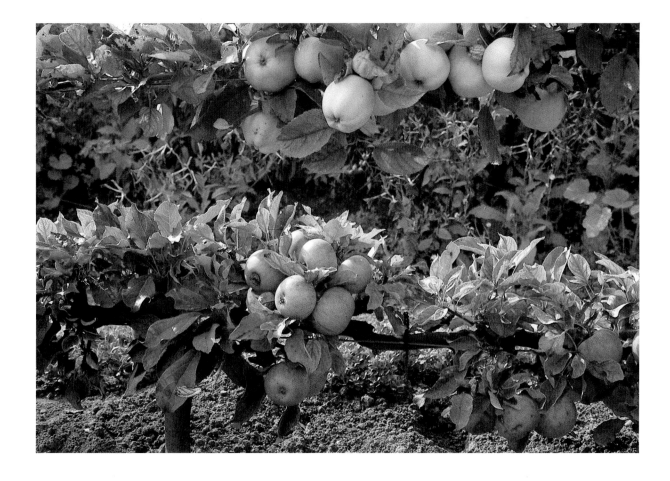

Normandy is known for its apples, and an "apple fence" is a charming and fruitful way to create a light open boundary in the garden. Pink nicotiana blooms beyond the ripe apples.

44 Rich mauves to blue-violet
and rose are embroidered
into the garden tapestry
in autumn with perennial
asters or Michaelmas dai-
sies. These many species of
spectacular lilac flowered
plants (A. *frikartii,* A.
*novae-anglia* and A. *novi-
belgii)* grow three to four
feet tall and usually require
staking. *Aster frikartii* is
native to the Himalayas
and begins its abundant
bloom of single daisy-like
flowers in May and contin-
ues to October. Many rich
color blends of white,
cream, pink, rose, lavender,
purple and blue are avail-
able with perennial asters.
They are an essential
plant to use for weaving an
autumn garden tapestry.

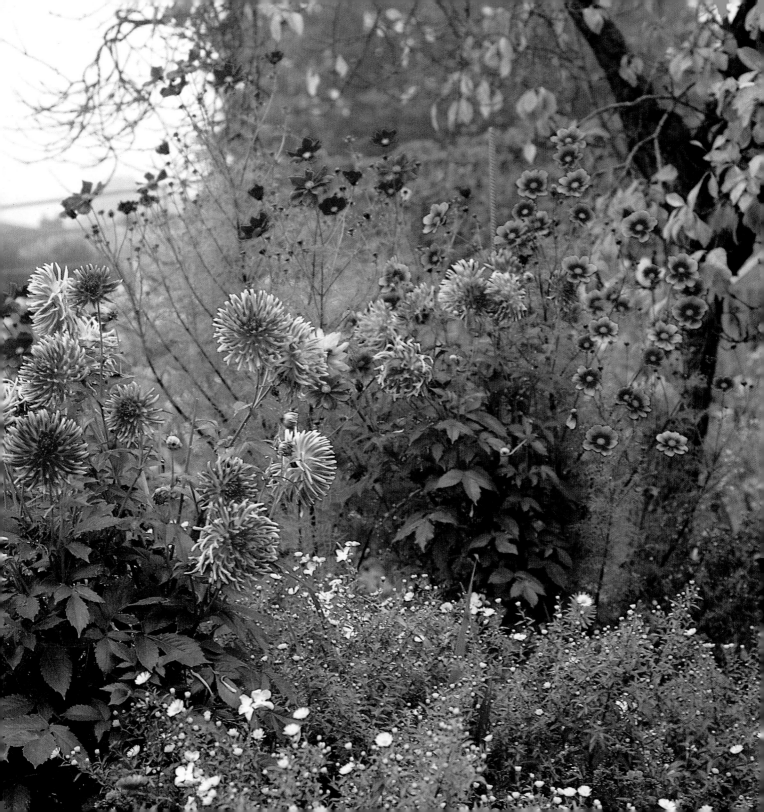

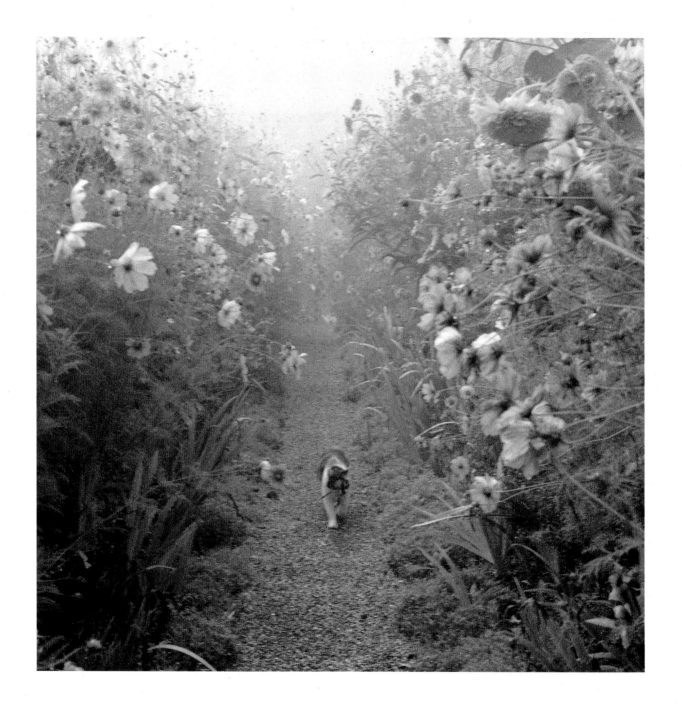

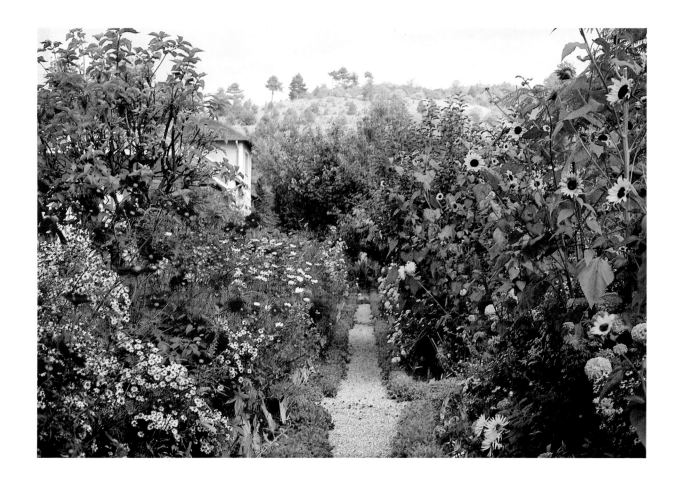

*Left:* "Fifi," the calico cat who resides in Monet's garden, takes an early morning stroll down one of the many narrow gravel paths. Pink cosmos and golden sunflowers tower above her in the silver mist of dawn.

*Above:* A monochrome flower bed of white, pink and red asters and cosmos is planted in front of the pink stucco second studio. A narrow gravel path separates the golden toned flower borders of sunflowers, marigolds, dahlias and scarlet orange Mexican sunflowers *(Tithonia rotundifolia)*. The clear color zones of red and gold flowers makes a strong statement because they are grouped together in monochrome masses rather than mixed together.

50

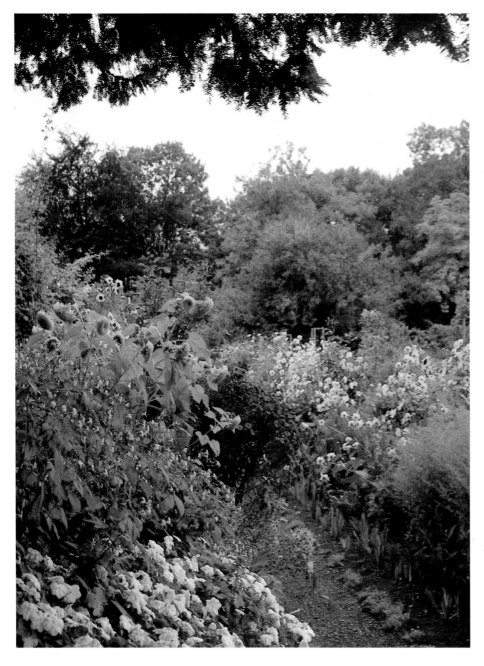

The pewter grey sky of autumn is illuminated by sparkling golden flowers that catch the low light. Yellow confetti leaves are informally scattered across the paths. The garden offers all its remaining flowers as the weather cools and apples ripen—the heavenly feast before the winter dormancy.

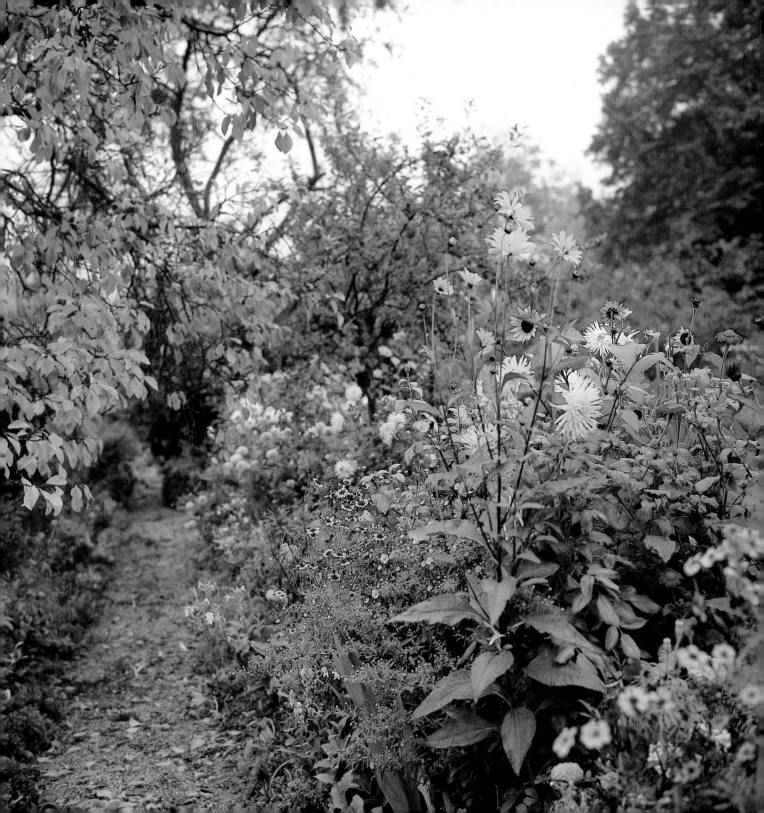

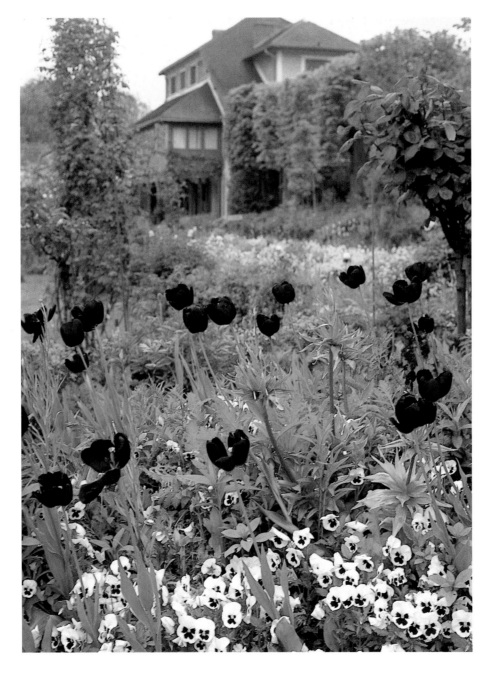

The Grande Allée is the main axis of the Clos Normand Garden, unifying the flower garden with the Japanese waterlily garden. This flower tunnel frames the house with 13-foot-high arches of rambling roses. In early spring the broad walk appears much wider without the creeping nasturtiums *(Tropaeolum)*. White pansies with black faces are planted over 'black knight' tulips under one of the iron arches.

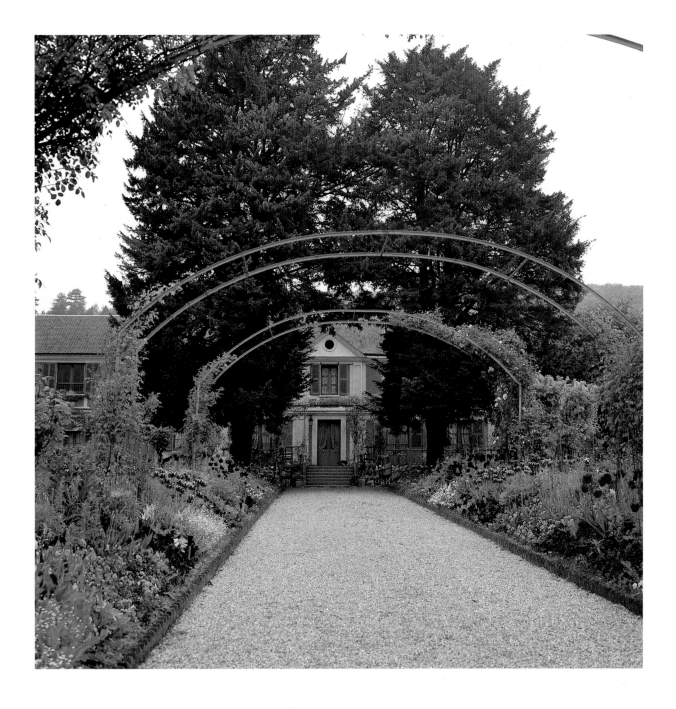

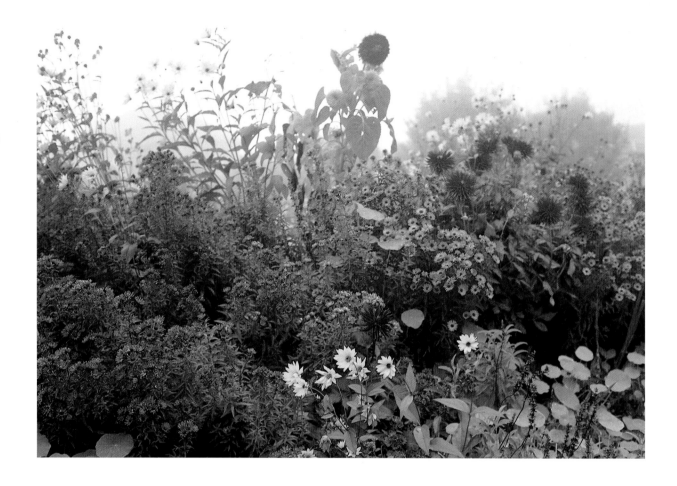

By September and October the nasturtiums have taken over the Allée, and the rambling roses have scrambled up the arches completing the tunnel effect. The seven-foot-wide borders raised two feet high are blooming in profusion. The tallest flowers are planted on top of the raised bed with progressively shorter flowers growing down the sides to the trailing nasturtiums.

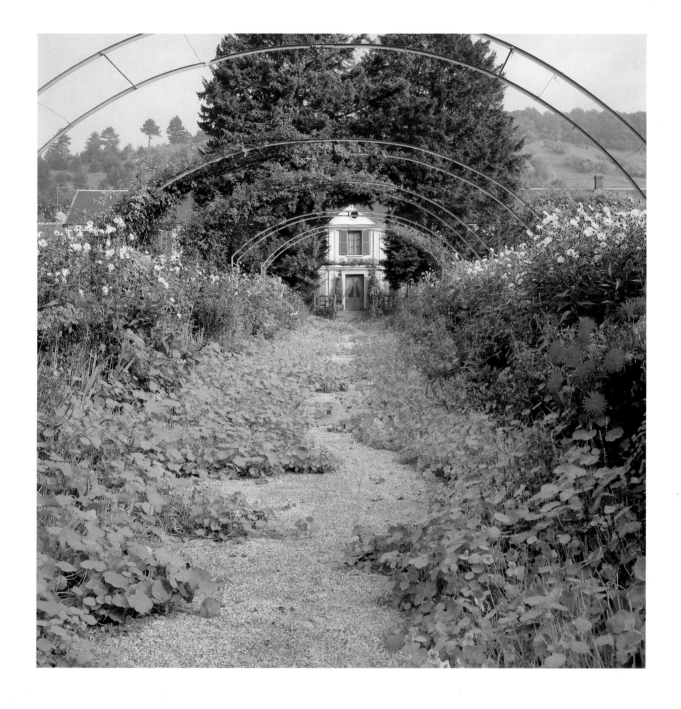

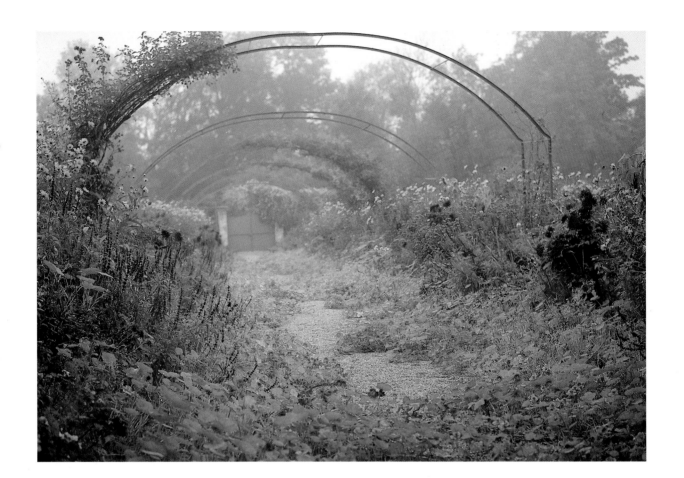

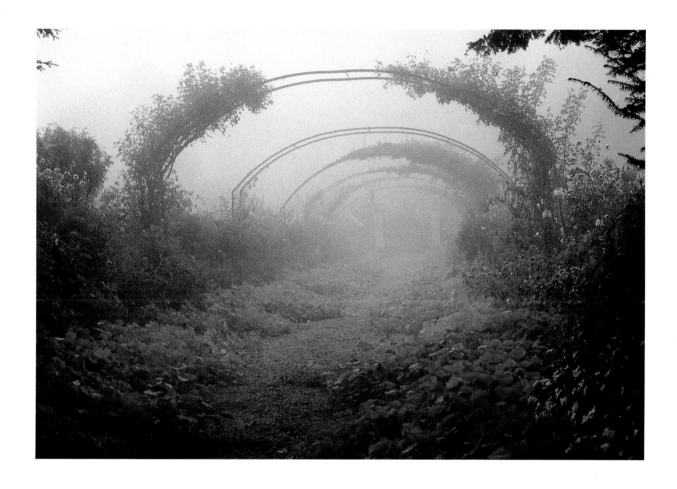

When mist enshrouds the Grande Allée, a silver luminescent veil softens all the colors and shapes. Throughout his life Monet strove to capture on canvas the effects of atmospheric conditions and variations in light on color and mood, and he successfully designed his garden to emphasize these illusive qualities.

MONET'S GARDEN TODAY

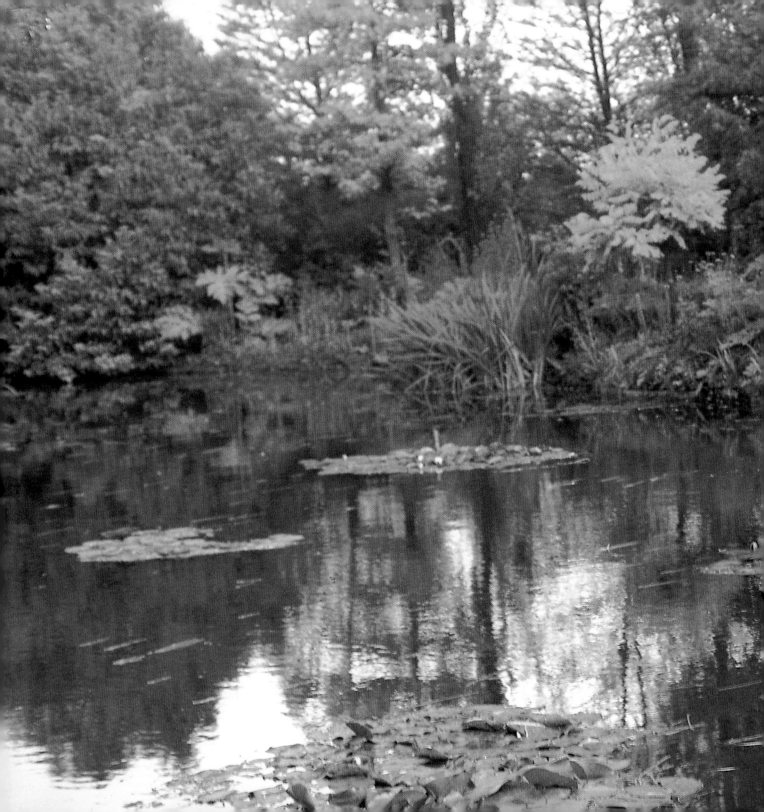

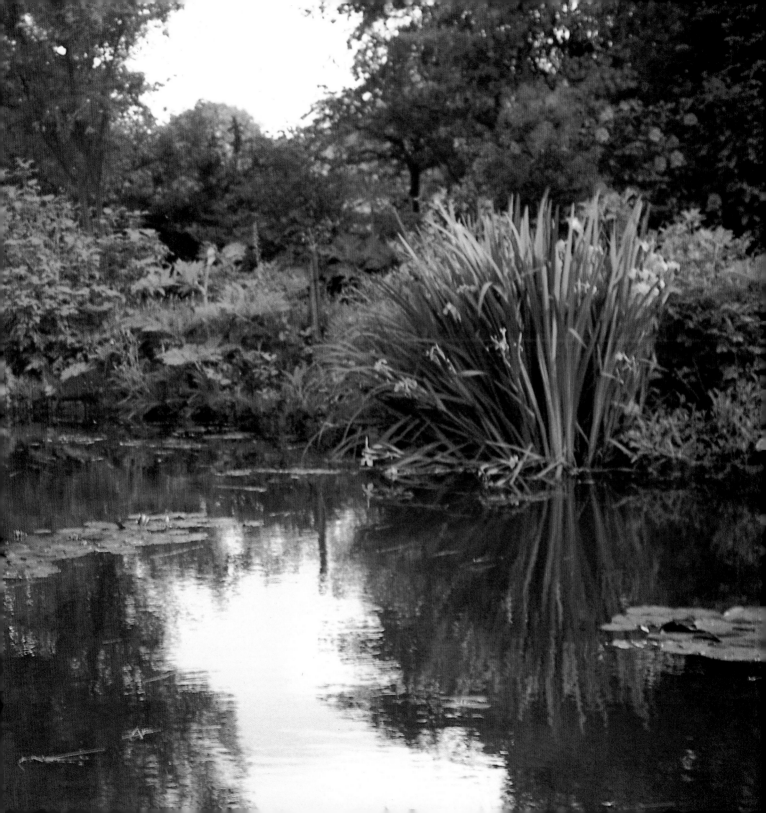

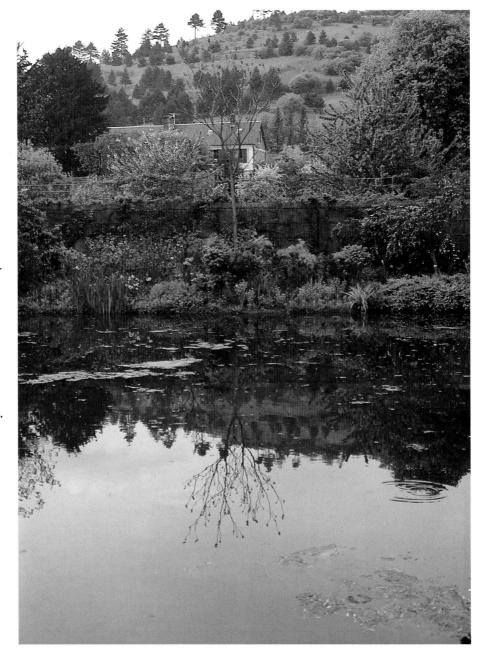

60 *Previous page:* The feelings and mood of Monet's two gardens are completely different. The Clos Normand is a myriad of color, a floral kaleidoscope ever changing according to the season and the carefully considered color scheme. In autumn it looks like a wonderful happenstance of "orderly disorder," restraint abandoned for spontaneity. The water-lily garden is much more quiet and tranquil with a dominance of green foliage and blue-green flowered water. The humped-back Japanese footbridge continues the Grande Allée axis straight through the garden. Light and reflections are the intricate design feature here. The air even smells different, less floral and more like green water and leaves. The feeling is more serene. Many traditional Japanese garden elements are borrowed, and many of the plants are native to Japan.

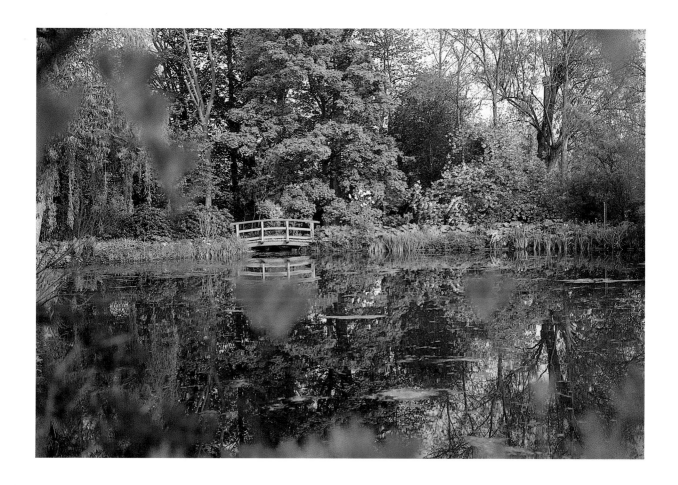

Water is the main element in Japanese gardens; here, the pond is the central theme. The bridge design was inspired from one of the many Japanese woodblock prints Monet admired. The use of the "borrowed landscape" theory, enjoying continuing views of the pastures and meadows beyond the garden boundaries, is typically Japanese. The garden appears much bigger and more natural than if it were enclosed with a solid wall or fence.

A labyrinth of gravel paths that twist, wind and inter-cross as they encircle the pond, gives the illusion of a grand park. The entire water garden area is just under 1½ acres, approximately 60,000 square feet, but it appears much bigger. Bamboo creates a tunnel effect over one path, and the round leaves of petasites *(P. japonicus)* and the ser-rated foliage of gunnera *(G. manicata)* line the walk. Pink blossoming cherry trees hang over the Rû, the stream that Monet diverted to supply his pond with water.

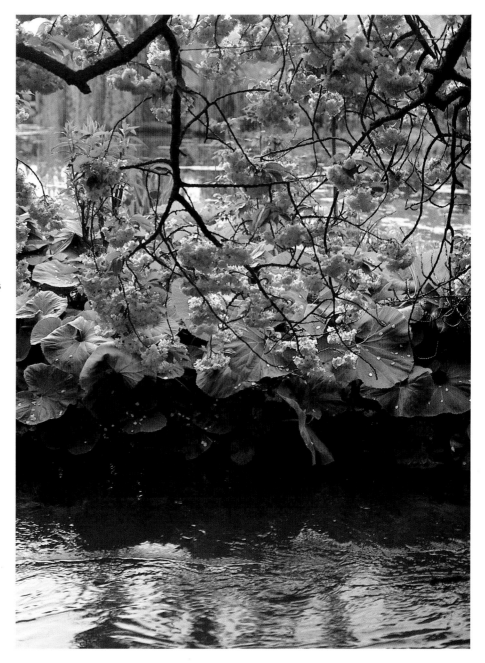

MONET'S GARDEN TODAY

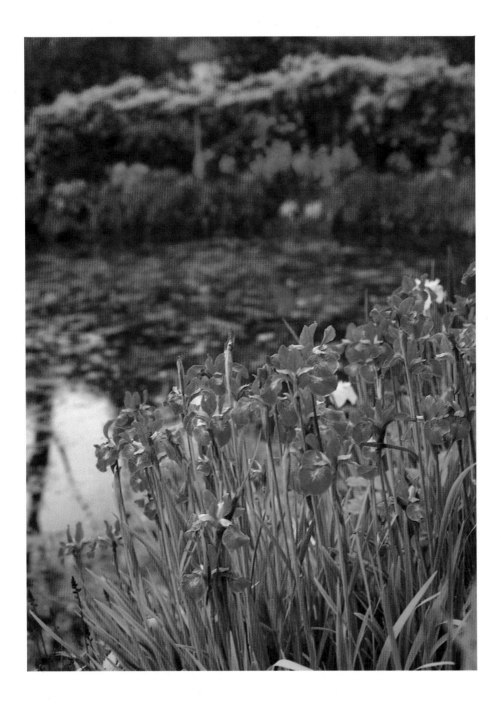

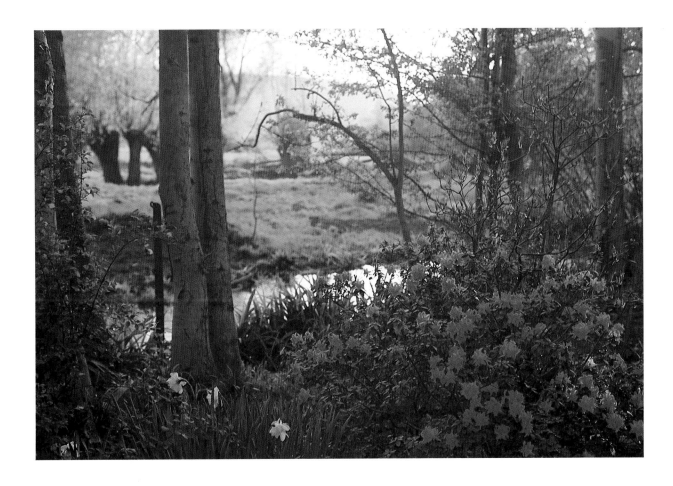

Stunning blue-violet Siberian iris grace the side of the waterlily pond. They enjoy full sun and plenty of water, so they are well placed for their cultural requirements as well as for the color, form and style they add to the pondscape. A lavender rhododendron is the perimeter plant marking the end of the cultivated garden and the beginning of the "borrowed landscape" of open meadows.

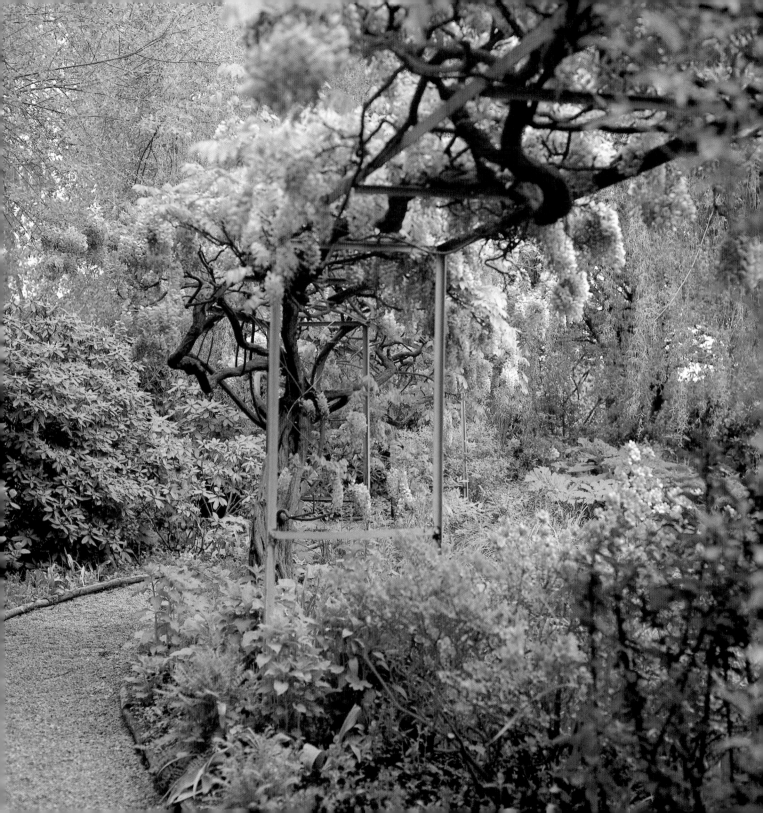

This original Japanese wisteria *(W. floribunda)* grows in the same place Monet planted it over 75 years ago. The iron arbor is 34 feet long and borders the northeast edge of the pond. It is underplanted with pink azaleas. The fragrant 18-inch-long blossoms echo the blooms of the wisteria on the Japanese bridge across the pond.

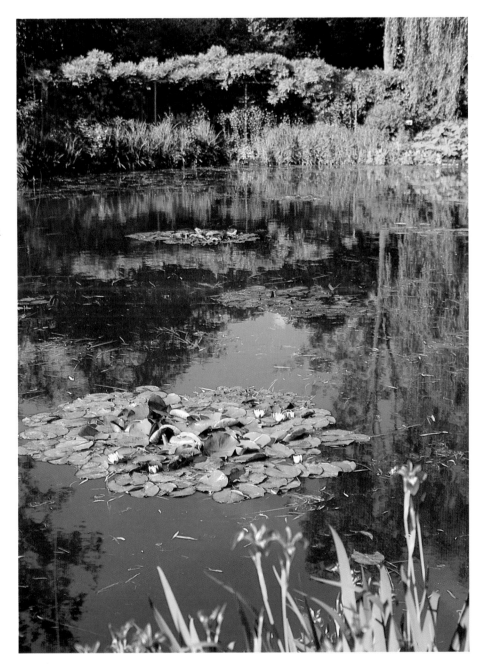

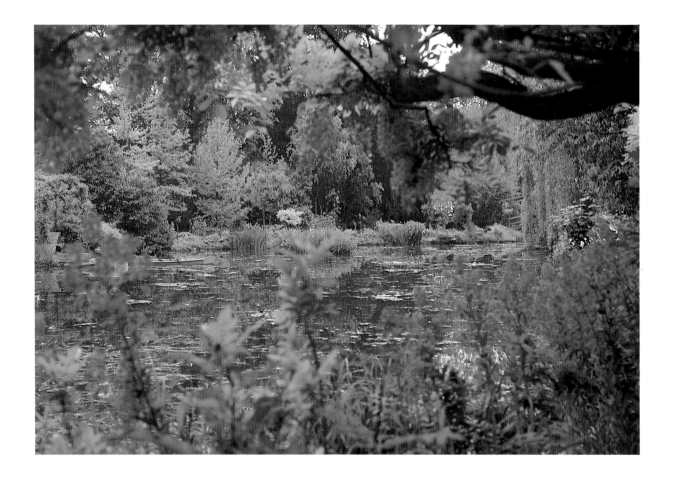

An impressionistic study of lavenders and greens appears through the mauve wisteria and purple lunaria *(L. annua)*.
In the summer the lunaria will form round, flat, green seed pods, which will dry and become the silver-white "money plant"
excellent for dried bouquets and catching reflected moonlight.

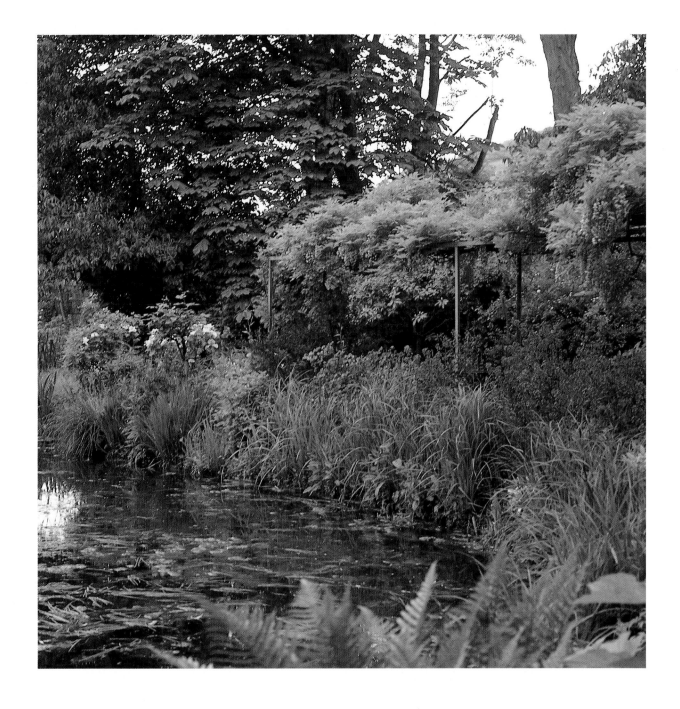

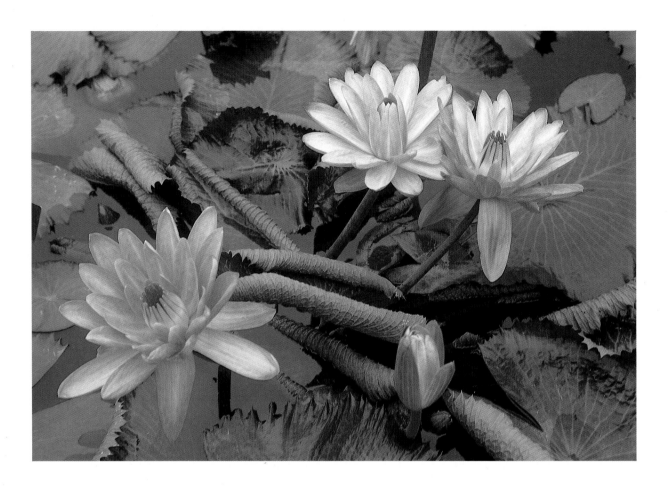

Waterlilies *(nymphaea)* are the flower jewels that decorate the pond and add substance to all the reflective patterns. There are hardy and tropical varieties. Monet grew both varieties, the tropicals for their beautiful blue and purple shades and longer-blooming season, even though the tubers required removal for the cold winter. Waterlilies range in color from white and yellow to copper, pink and red. Monet planted the lilies in tubs and placed the colors in harmonious blends.

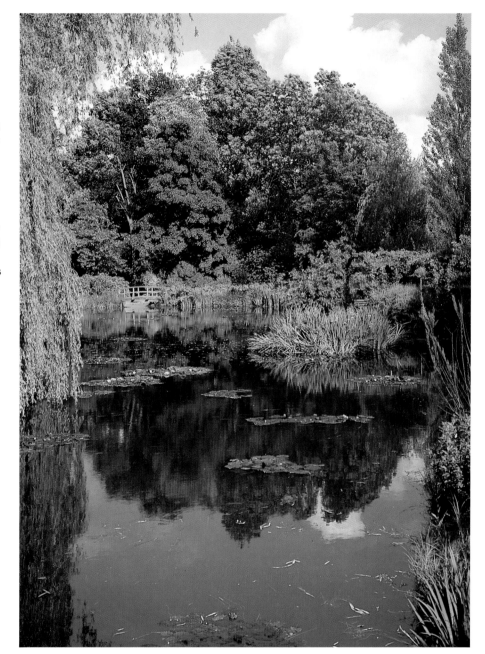

MONET'S GARDEN TODAY

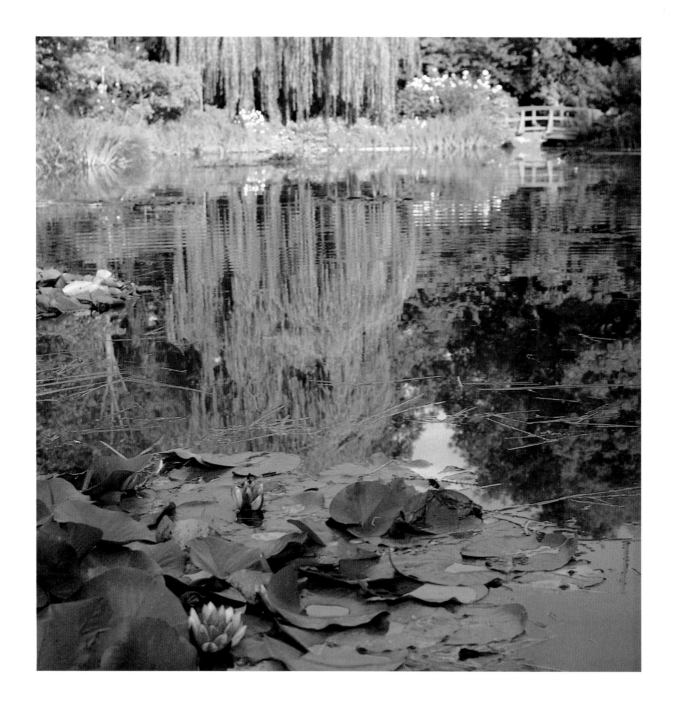

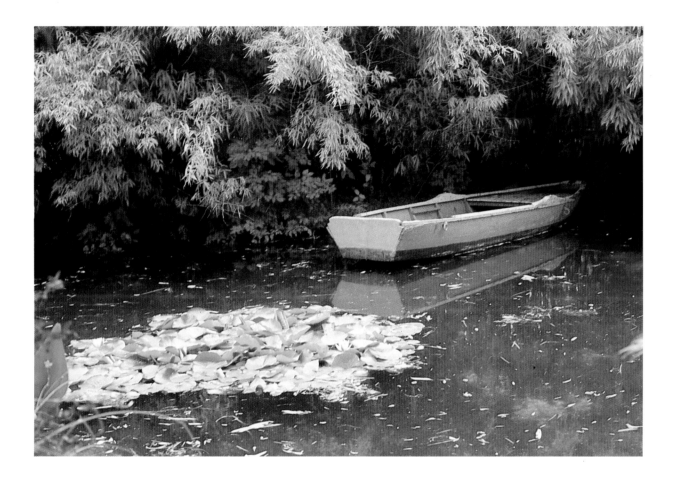

A special gardener was assigned to take care of the pond. Early in the morning before Monet began painting, this gardener rowed a little boat about the pond, cleaning the surface of any algae or grasses, grooming plants of spent flowers and leaves and rinsing dust off the floating flowers. Monet insisted that the water be as clean as a mirror and that the spreading waterlilies be trimmed in a circular pattern. He directed the shapes of solid waterlilies and the negative spaces of the reflecting water.

MONET'S GARDEN TODAY

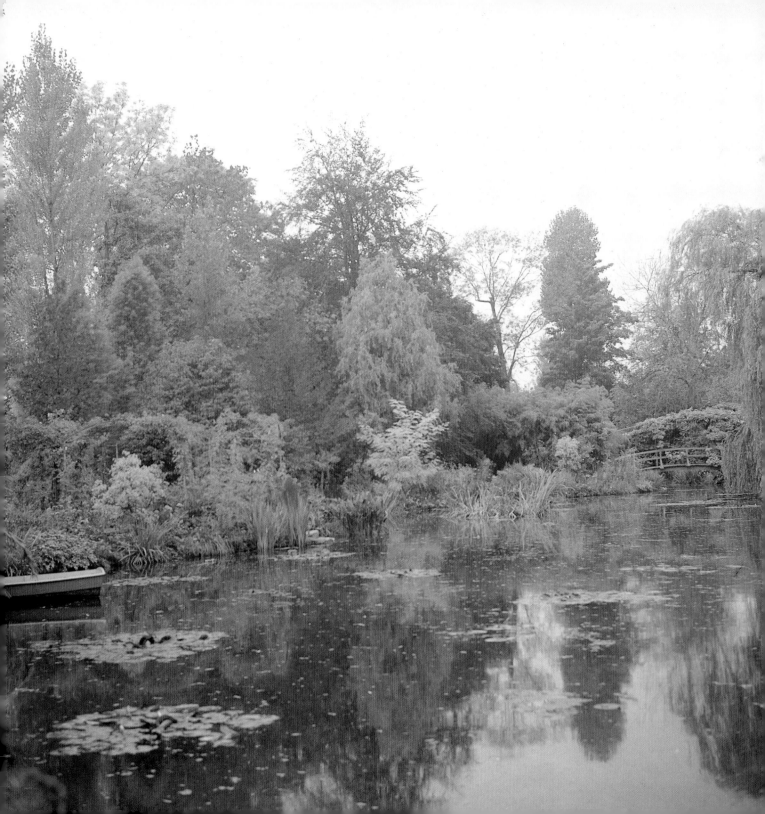

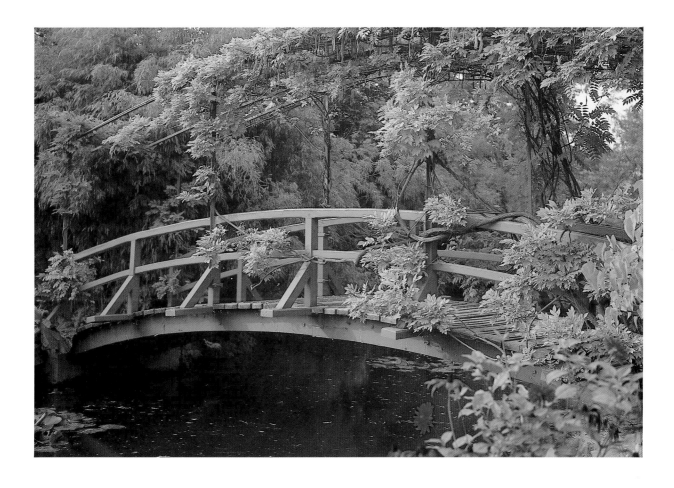

In autumn, as flowers fade around the pond, the richly colored foliage of the many trees dominate the visual splendor. Red liquidambar, maroon copper beech *(Fagus atropunicea)* and yellow-green poplars *(Populus nigra)* bring color up into the sky. The velvet stringbean-like seed pods of the wisteria hang as harvest offerings on the Japanese footbridge.

MONET'S GARDEN TODAY

A rich plum Christmas rose *(Helleborus niger)* blooms beside the pond from December to April, providing flowers through the cold winter months.

In winter when the trees are dormant and the waterlilies are resting, majestic white cumulus clouds float across the mirroring water in shimmering transitions of blue and white.

MONET'S GARDEN TODAY

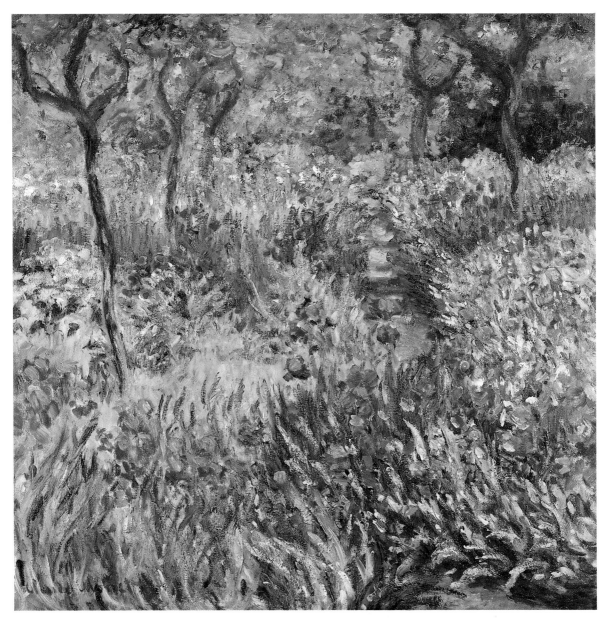

Claude Monet. *The Artist's Garden at Giverny,* 1900. Oil on canvas, 35¼ x 36¼ in. Yale University Art Gallery. Gift of Mr. and Mrs. Paul Mellon, B.A. 1929.

# BRINGING GIVERNY HOME: IDEAS FROM MONET'S GARDENS

*"More than anything,
I must have flowers,
always, always."*
Claude Monet

CLAUDE MONET'S gardens were a continual inspiration to him, and today they live on influencing and enriching all the thousands of people who visit them each year. There are many lessons we can learn from the way Monet designed his gardens: using succession planting by weaving bulbs and annuals into perennial borders to provide color for all seasons; using scale and borrowed landscape to increase the visual size of the garden; using large blocks of monochromatic colors for impact or placing complementary colors next to each other for increased intensity; using specific color to increase atmospheric effects of mist or sunlight; and using reflections of the sky and landscape on the surface of water as a design feature.

Just as painters must continually practice and train their eyes with hundreds of sketches, so must garden artists experiment and learn about blending the multitudes of flower and foliage color, texture and shapes. Flower arranging is an excellent vehicle for such practice. Working with fresh plant material and choosing pleasing combinations in a hand-held bouquet or a more formal "line" arrangement can be a very beneficial exercise. The designer can work directly with the cut flowers and not be restricted by the constraints of growing requirements and orchestrating blooming periods.

If you decide to plan your own flora composition, establish your plant palette by proceeding through these steps:

Establish your needs:
- time of bloom desired (spring, summer or autumn)
- colors that please you and that complement your environment or home interiors. (If you have a dominant feature in or near your garden that you want to emphasize, like a seasonally blooming tree, autumn foliage, or a colorful house or other strong architectural element, choose plants to complement and accentuate its colors.)
- time and cost of installation and maintenance, including a watering system

Select your plants:
- Familiarize yourself with the optimum uses of bulbs, annuals, perennials, vines, shrubs, grasses and trees.
- Learn which plants are native to your area.
- Note the special characteristics of the plants you are considering, such as size, shape, and texture.
- Pay attention to the cultural requirements of the plants you are considering, including climate, sun, water, soil type and fertilizer.

After you have made decisions based on the above, draw up a list of the plants you know will bloom in your chosen colors at the same time in your climate. The more specific you are, the shorter your list will be.

The garden designs on the following pages use Monet's color theories and planning ideas. The island bed design can be set in a lawn or surrounded by paths. The Petite Allée with rose arches is presented in a scale many of us can plant in our gardens using five-foot-wide arches that are commercially available (see the list of sources on page 112.) The double monochromatic border features one side in blues and purples and the other side in shades of rose and lavender, which blend together beautifully. Finally, the last design draws upon Monet's own waterlily pond, experimenting with placement of waterlilies and surrounding plants to enhance the reflective qualities of the water garden.

These designs can be followed precisely, or they can serve as a take-off point for you to create your own painterly garden with layers of color and texture. The black line plans printed on the overlays show the layout of all the perennial plantings, which are the mainstay of the garden designs. The key for each design along with the color illustrations designate where annual bedding plants and bulbs are to be planted for continual color. If you decide not to follow these diagrams precisely, you may want to use them as a model for your own garden drawings. After you draw your own perennial garden plan (to scale), use a tracing paper overlay and fill in areas for spring bulbs with color pencils. A second sheet of tracing paper can be used to color in an annual overplanting of pansies or forget-me-nots, for example. This method will aid you in determining which colors combine well within the particular space limitations of your garden, and how changing seasonal colors will look from spring through autumn.

Please refer to the chapter on plant cultivation (page 99) for specific instructions for the planting and care of each plant used in the garden designs.

# ISLAND FLOWER BED
## ROSES AND PERENNIALS

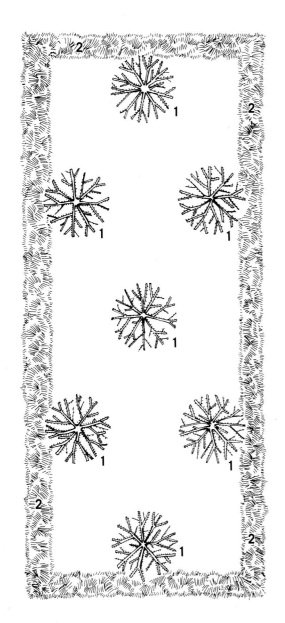

**1** 7 standard rose trees in pink

**2** 46 cottage pinks (*Dianthus plumarius*)

**Island bed dimensions:**
7 x 16 feet

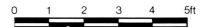

# INSTRUCTIONS

## Roses and Perennials

Raise the island bed 12 to 18 inches high by predigging the earth with a spading fork to lighten and aerate the soil. The raised bed will ensure good drainage. You may add organic soil amendments such as well-rotted manure, compost or leaf mold as you do this. Use string and four stakes to mark dimensions.

Plant the standard roses first. The "Queen Elizabeth" variety is a very easy-to-grow pink rose, used in the Giverny garden today.

Cottage pinks will help keep the soil in place and will create a distinct, pretty edge. Plant them along the raised edge or "curb" of the island bed, 1 foot apart, with 7 plants at both the top and bottom of the island and 16 plants on each side. If you plant cottage pinks in a zigzag pattern, they will have more room to grow and will form a thicker edge, but you will need twice as many plants (92). If you choose to use miniature dianthus, like "Tiny Rubies," you will need 150 plants. Cottage pinks need to be watered carefully until they are established, patting soil back in place where necessary.

## Spring Planting

Around November (time will vary according to your climate zone), plant 125 tulips, with half a light pink color and the other half a deeper rose pink. To lengthen their blooming time, mix single early varieties of Darwin hybrids and single late varieties (about 24 of each kind of tulip in each color). Mix the colors well, planting them 9 to 12 inches deep, 4 to 6 inches apart, with bonemeal or "bulb booster" fertilizer. Leave about 6 inches of space around the rose tree trunks.

Plant 100 biennial forget-me-nots over the bulbs, following local planting instructions. Biennials will winter over in most zones. Annual varieties may not, but they can be planted over the tulip bulbs in early spring in milder climates.

## Summer Planting

When the forget-me-nots have finished blooming and the tulip bulbs have yellowed and ripened, pull out the forget-me-nots and cut off the foliage of the bulbs. Plant 12 pink and 12 red geraniums, allowing 12 to 18 inches between the centers of the plants. For a pleasing monochromatic effect, it is essential that a clear pink geranium is used rather than a coral or salmon pink which have hints of orange. Also, a pure red geranium is preferable over the scarlet orange-red common geranium.

In mild climates where geraniums are year-round perennials, the spring planting of tulips can be omitted. For other climates, geraniums can be removed to the greenhouse to winter over, and cuttings can be taken for fresh, new summer plants.

84

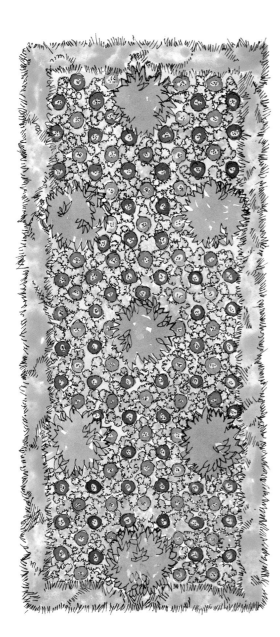

## ISLAND FLOWER BED
SPRING PLANTING

**Island bed dimensions:**
7 x 16 feet

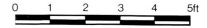

0  1  2  3  4  5ft

# ISLAND FLOWER BED
## SPRING PLANTING

**1** 7 standard rose trees in pink (shrubs)

**2** 46 cottage pinks (Dianthus plumarius) (perennials)

**A** 62 pink and 63 red tulips interplanted

**B** 100 blue forget-me-nots planted over tulip bulbs

*Numerical keys denote perennials; letter keys denote annuals.*

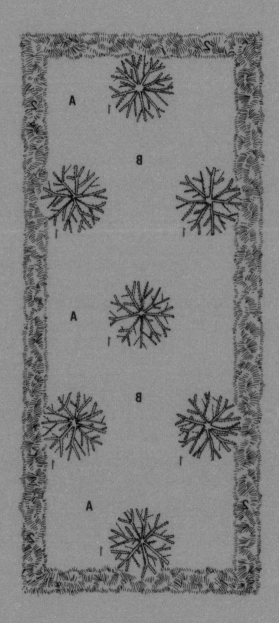

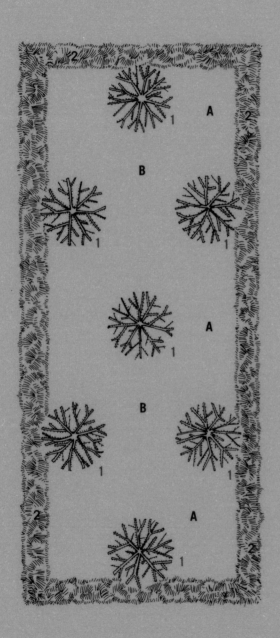

# ISLAND FLOWER BED
## SPRING PLANTING

**1**   7 standard rose trees in pink (shrubs)

**2**   46 cottage pinks *(Dianthus plumarius)* (perennials)

**A**   62 pink and 63 red tulips interplanted

**B**   100 blue forget-me-nots planted over tulip bulbs

Numerical keys denote perennials; letter keys denote annuals.

# ISLAND FLOWER BED
SUMMER/FALL
PLANTING

**1**  7 standard rose trees in
pink (shrubs)

**2**  46 cottage pinks *(Dianthus plumarius)* (perennials)

**C**  12 pink geraniums

**D**  12 red geraniums

Numerical keys denote perennials;
letter keys denote annuals.

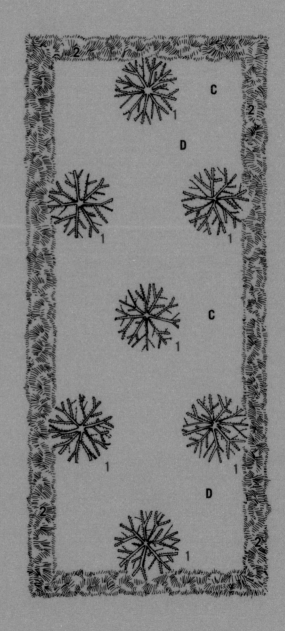

# ISLAND FLOWER BED
## SUMMER/FALL PLANTING

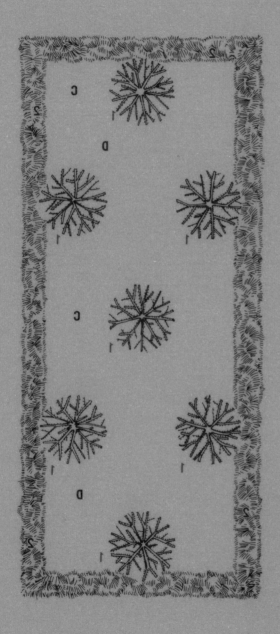

**1**   7 standard rose trees in pink (shrubs)

**2**   46 cottage pinks (*Dianthus plumarius*) (perennials)

**C**   12 pink geraniums

**D**   12 red geraniums

*Numerical keys denote perennials; letter keys denote annuals.*

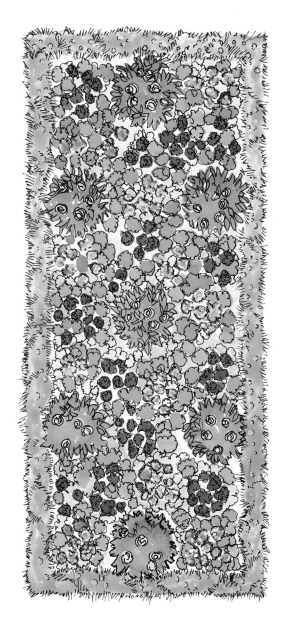

# ISLAND FLOWER BED
SUMMER/FALL
PLANTING

**Island bed dimensions:**
7 x 16 feet

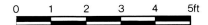

0   1   2   3   4   5ft

# A PETITE ALLÉE
## SHRUBS AND PERENNIALS

**\*\*1** 6 climbing roses, yellow, red or orange (shrubs)

**\*\*2** 10 asters in violet and purple (perennials)

**\*\*3** 10 sunflowers (*Helianthus multiflorus*) (perennials)

**\*4** 16 blue delphiniums (perennials)

**\*5** 30 lavender/violet aubrieta (perennials)

**\*6** 56 lavender/purple bearded iris (perennials)

**\*7** 4 red oriental poppies (perennials)

**\*8** 6 yellow leopard's bane (perennials)

\*These plants bloom in spring.
\*\*These plants bloom in summer/ fall.

**Overall dimensions:**
*each bed:* 4 x 15 feet
*path:* 3 feet wide
*arches:* 5 feet wide

0  1  2  3  4  5ft

# INSTRUCTIONS

## General Layout

Prepare raised beds 12 to 18 inches high. Use string and stakes to measure out beds 4 feet wide and 15 feet long with a 3-foot-wide path in between. Place 3 steel rose arches 5 feet wide and 8 feet high across the path, positioning the middle one first with the others spaced at 4 feet out from the center arch.

## Shrubs and Perennials

First plant a climbing rose at each of the bases of the arches. The asters, sunflowers and delphiniums should be planted in equal numbers on each side of the path, with the asters about 2 feet from the inside edge. Plant 15 aubrieta on each outside border in a zigzag pattern, followed by 28 bearded iris on each side just inside the aubrieta. Plant each leopard's bane near the roses at the inside base of each arch. Place oriental poppies according to diagram.

These perennials will generally grow best if planted in the autumn and allowed to establish themselves before a hard freeze, but planting them in the spring can also yield hardy plants.

## Spring Planting

Plant the dutch iris bulbs in the fall in cold climates 3 to 6 inches apart, with 36 on each side of the *allée* inside of the bearded iris. In milder climates, autumn planting will result in winter bloom.

The pansies and English primroses should be planted on each side to fill in open areas. Plant them over the bulbs in mild-winter areas, providing winter color. In colder climates, plant them in early spring when the ground thaws. Many primroses will thrive for years in cool climates, but the pansies will have to be replaced each year. Remove them when they are finished.

## Summer/Fall Planting

In May, just when the spring garden is looking its best, it is time to plant extra color for summer and autumn. The red cactus dahlias should be planted (8 on each side) only after any danger of frost has passed. The plants will bloom from August until the first frost of the following season. Remove the bulbs and store them in a dry, dark, cool place over winter.

The sunflowers will be most effective planted by seed in groups of 3 down the middle of each bed. Plant the nasturtiums, as well, by seed in a zigzag pattern along the inside edge of the beds.

# A PETITE ALLÉE
SPRING PLANTING

**Overall dimensions:**
*each bed:* 4 x 15 feet
*path:* 3 feet wide
*arches:* 5 feet wide

# A PETITE ALLÉE
## SPRING PLANTING

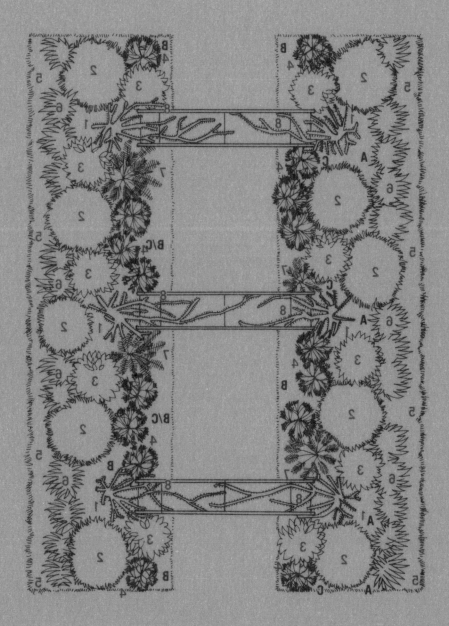

1   6 climbing roses, yellow, red or orange (shrubs)

2   10 asters in violet and purple (perennials)

3   10 sunflowers (*Helianthus multiflorus*) (perennials)

*4   16 blue delphiniums (perennials)

*5   30 lavender/violet aubrieta (perennials)

*6   56 lavender/purple bearded iris (perennials)

*7   4 red oriental poppies (perennials)

*8   6 yellow leopard's bane (perennials)

*A   72 wedgewood-blue Dutch iris

*B   60 blue pansies

*C   60 blue English primroses

*Numerical keys denote perennials; letter keys denote annuals.*

*\* These plants bloom in spring.*

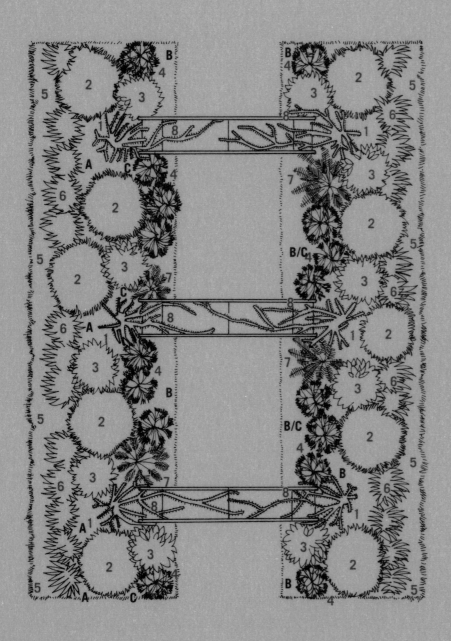

# A PETITE ALLÉE
SPRING PLANTING

**1** 6 climbing roses, yellow, red or orange (shrubs)

**2** 10 asters in violet and purple (perennials)

**3** 10 sunflowers (*Helianthus multiflorus*) (perennials)

*4 16 blue delphiniums (perennials)

*5 30 lavender/violet aubrieta (perennials)

*6 56 lavender/purple bearded iris (perennials)

*7 4 red oriental poppies (perennials)

*8 6 yellow leopard's bane (perennials)

*A 72 wedgewood-blue Dutch iris

*B 60 blue pansies

*C 60 blue English primroses

Numerical keys denote perennials; letter keys denote annuals.

*These plants bloom in spring.

# A PETITE ALLÉE
SUMMER/FALL
PLANTING

*1  6 climbing roses, yellow, red or orange (shrubs)

*2  10 asters in violet and purple (perennials)

*3  10 sunflowers (*Helianthus multiflorus*) (perennials)

*4  16 blue delphiniums (perennials)

5  30 lavender/violet aubrieta (perennials)

6  56 lavender/purple bearded iris (perennials)

7  4 red oriental poppies (perennials)

8  6 yellow leopard's bane (perennials)

*D  16 dahlias, the red cactus variety

*E  18 annual sunflowers

*F  nasturtiums

Numerical keys denote perennials; letter keys denote annuals.

*These plants bloom in summer/fall.

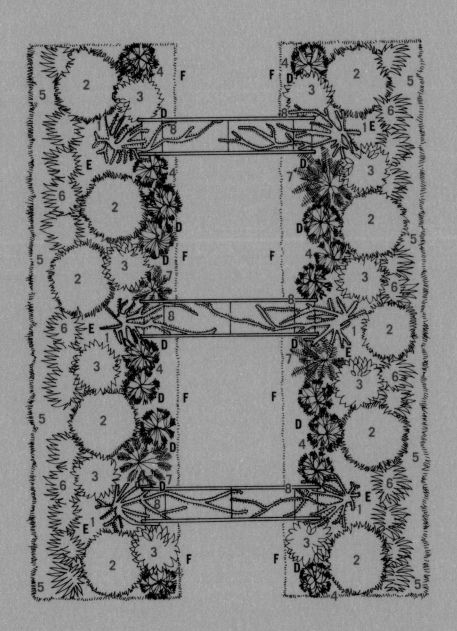

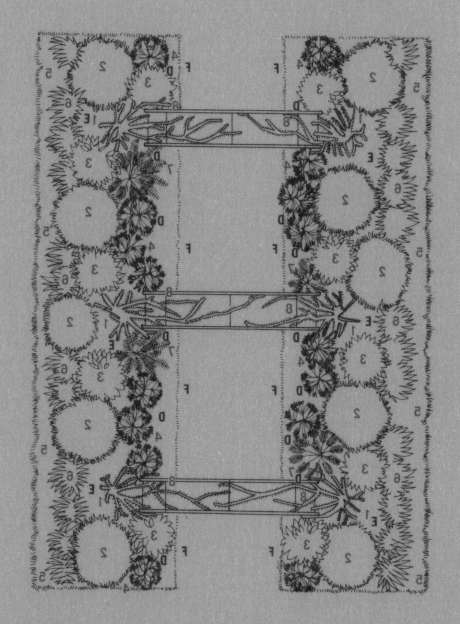

# A PETITE ALLÉE
## SUMMER/FALL
## PLANTING

*1 6 climbing roses, yellow, red or orange (shrubs)

*2 10 asters in violet and purple (perennials)

*3 10 sunflowers (Helianthus multiflorus) (perennials)

*4 16 blue delphiniums (perennials)

5 30 lavender/violet aubrieta (perennials)

6 56 lavender/purple bearded iris (perennials)

7 4 red oriental poppies (perennials)

8 6 yellow leopard's bane (perennials)

*D 16 dahlias, the red cactus variety

*E 18 annual sunflowers

*F nasturtiums

Numerical keys denote perennials; letter keys denote annuals.

*These plants bloom in summer/fall.

# A PETITE ALLÉE
SUMMER/FALL
PLANTING

**Overall dimensions:**
*each bed:* 4 x 15 feet
*path:* 3 feet wide
*arches:* 5 feet wide

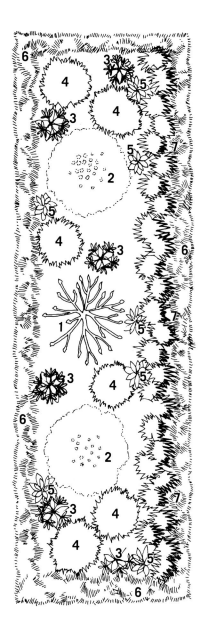

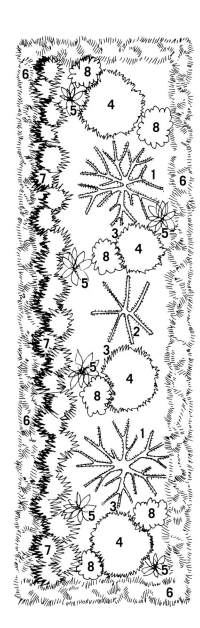

# DOUBLE MONOCHROMATIC BORDERS
## PERENNIALS

**Left Side** (Blue):

*1   1 standard lavender lilac tree

*2   2 single white tree peonies

*3   6 blue lupine or delphiniums

**4   6 asters; 3 *A. frikartii* and *A. novi-belgii*

***5   7 silver lamb's ears

*6   40 blue aubrieta

*7   27 blue bearded iris

**Right Side** (Pink):

**1   2 old-fashioned single pink shrub roses

**2   1 cane rose in deep pink

*3   3 mauve delphiniums

**4   4 asters in pink and rose colors

***5   6 silver lamb's ears

*6   40 pink aubrieta

*7   27 rose-color bearded iris

**8   6 pink hollyhocks

*These plants bloom in spring.
**These plants bloom in summer/fall.
***These plants bloom in spring and summer/fall.

**Overall dimensions:**
*each border:* 5 x 16 feet
*path:* 3 feet wide

0   1   2   3   4   5ft

# INSTRUCTIONS

**General Layout**

Prepare raised beds 12 to 18 inches high. Use string and stakes to measure out beds 5 feet wide and 16 feet long with a 3-foot-wide path between.

**Perennials**

After planting the lilac tree and tree peonies (left side) and the shrub roses and cane rose (right side), plant the lupine (or delphiniums), asters and lamb's ears. The 3 *Aster frikartii* should be planted in the back of the border, while the 3 *Aster novi-belgii* should be placed nearer the path, as they are shorter. Plant the aubrieta on each outside border in a zigzag pattern 12 inches apart. (You may substitute candy tuff (white or lavender for the left side, white or pink/rose for the right side) or lavender-blue *Phlox divaricata* (left side only) for the aubrieta.) Then plant the bearded iris just inside the aubrieta.

**Spring Planting**
**Left Side** (Blue)

Plant the Siberian squill 6 inches deep (to allow for overplanting of other annuals) and 3 to 6 inches apart in the fall in an informal drift behind the bearded iris. The result will be a mass of color when the squill blooms in the spring. (You may substitute Dutch iris or grape hyacinth for the Siberian squill.) The pansies and English primroses should be planted to fill in gaps. Plant them over the bulbs in mild-winter areas, providing winter color. In colder climates, plant them in early spring when the ground thaws. The pansies look best planted in groups of 3 or 5, and they can be removed from the garden when they are finished.

The forget-me-nots also should be planted over the bulbs, informally, to fill in gaps. Use biennial or perennial forget-me-nots if you plant them in the fall, but annual forget-me-nots can be planted in the spring.

**Right Side** (Pink)

The 40 tulip bulbs should be planted in an informal drift behind the bearded iris. Place them 9 to 12 inches deep in the fall. Combine early and late Darwin varieties for longer blooming time. Use bonemeal or "bulb booster" fertilizer.

Plant the pansies to fill in the open areas over the bulbs in mild-winter areas; in colder climates, plant them in early spring when the ground thaws. Remove the pansies when they are finished.

The pink forget-me-nots are to be planted over the tulips informally, again, to fill in gaps. (Pink varieties are harder to find than the blue, but the sources list at the back of this book will assist you in locating them.) The plants can be started by seed indoors over winter, and the established plants can be planted after the ground thaws in spring.

**Summer/Fall Planting**
**Left Side** (Blue)

Plant the seeds of cosmos and salvia in early May directly into the border or in flats, transplanting established bedding plants in late May or early June. Plant the cosmos in groups of 3 at the back of the border; place the salvia behind the iris after the forget-me-nots have finished.

**Right Side** (Pink)

The pink cosmos should be planted in the same manner and at the same time as the cosmos and salvia are planted for the left side of the border. Plant the cactus dahlias after all danger of frost has passed. The plants will bloom from August until the first frost of the following seasons. Remove the bulbs and store them in a dry, dark, cool place over winter.

## DOUBLE MONOCHROMATIC BORDERS
SPRING PLANTING

**Overall dimensions:**
*each border:* 5 x 16 feet
*path:* 3 feet wide

0   1   2   3   4   5ft

**Left Side (Blue):**

A* 40 clear blue Siberian squill

B* 24 blue pansies

C* 24-30 Wedgewood and dark blue English primroses

D* 36 forget-me-nots

**Right Side (Pink):**

A* 40 mauve and pink tulips

B* 36 pink forget-me-nots

C* 24 pink, rose and white pansies

*See diagram on page 90 for identifying perennials.*

*Letter keys denote annuals.*

**These plants bloom in spring.*

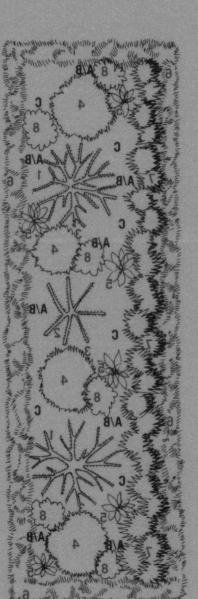

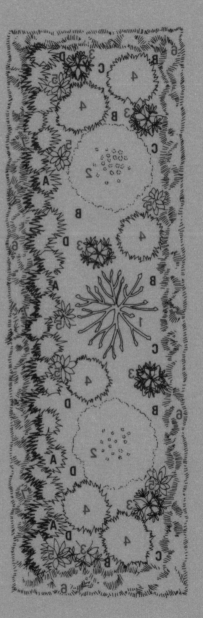

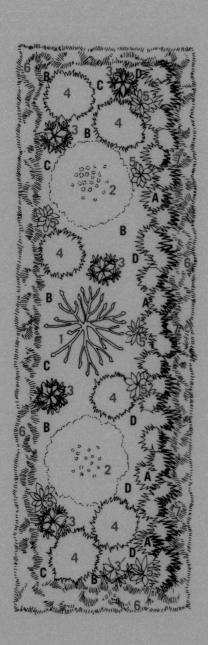

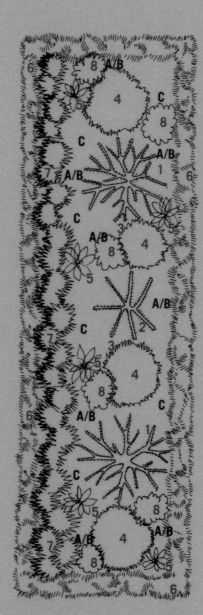

# DOUBLE MONOCHROMATIC BORDERS
## SPRING PLANTING

**Left Side** (Blue):

*A  40 clear blue Siberian squill

*B  24 blue pansies

*C  24-30 Wedgewood and dark blue English primroses

*D  36 forget-me-nots

**Right Side** (Pink):

*A  40 mauve and pink tulips

*B  36 pink forget-me-nots

*C  24 pink, rose and white pansies

**See diagram on page 90 for identifying perennials.**

Letter keys denote annuals.

*These plants bloom in spring.

# DOUBLE
# MONOCHROMATIC
# BORDERS
SUMMER/FALL
PLANTING

**Left Side** (Blue):

*E  18-24 white cosmos

*F  24-30 blue salvia

**Right Side** (Pink):

*D  18-24 pink cosmos

*E  5 cactus dahlias (or
     singles) in pink

**See diagram on page 90 for
identifying perennials.**

Letter keys denote annuals.

*These plants bloom in
  summer/fall.

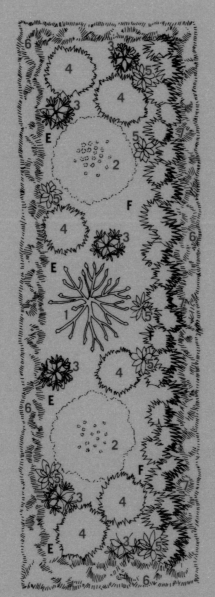

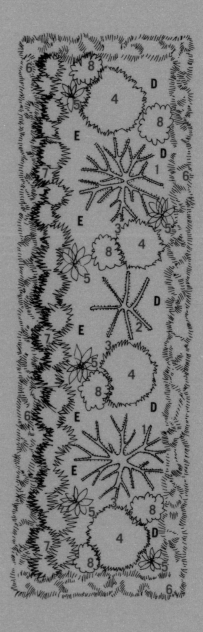

# DOUBLE MONOCHROMATIC BORDERS
## SUMMER/FALL PLANTING

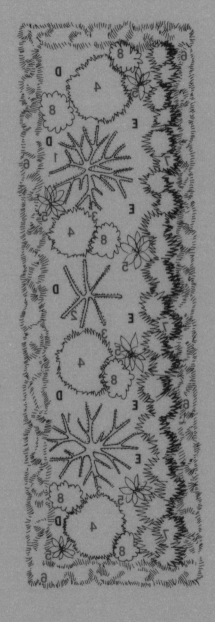

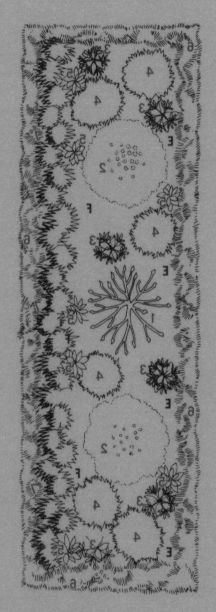

**Left Side (Blue):**

E.* 18-24 white cosmos

F.* 24-30 blue salvia

**Right Side (Pink):**

D.* 18-24 pink cosmos

E.* 5 cactus dahlias (or singles) in pink

*See diagram on page 90 for identifying perennials.*

Letter keys denote annuals.

*These plants bloom in summer/fall.

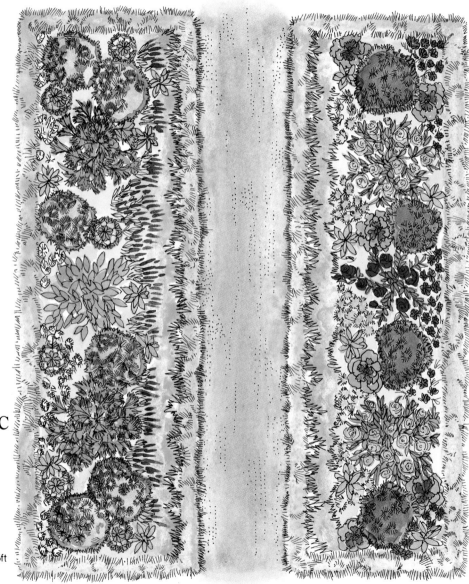

# DOUBLE MONOCHROMATIC BORDERS
SUMMER/FALL
PLANTING

**Overall dimensions:**
*each border:* 5 x 16 feet
*path:* 3 feet wide

0   1   2   3   4   5ft

# A WATER GARDEN

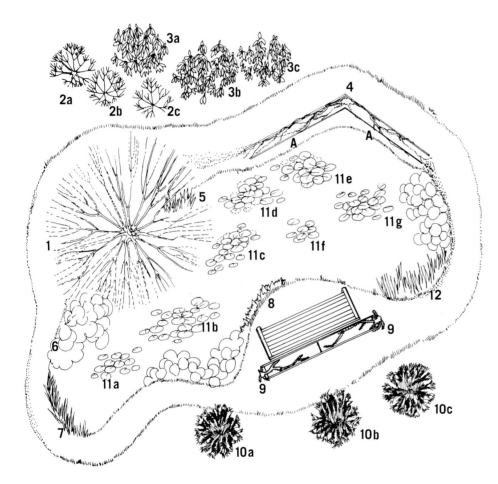

1. 1 willow tree

2. 3 azaleas (2a: coral pink; 2b: lavender pink; 2c: pink)

3. 3 rhododendrons (3a: lavender; 3b: pink; 3c: crimson-pink)

4. 1 wisteria

5. 3 lavender bearded iris

6. 3 sweet coltsfoot

7. 3 yellow daylilies or blue lilies-of-the-Nile

8. 3 arrowhead

9. 2 climbing roses in pink, yellow or coral

10. 3 tree peonies, the Japanese-style single variety (10a: pale yellow; 10b: coral with yellow center; 10c: pink with yellow center)

11. 7 waterlilies, hardy and tropical varieties (11a: white with yellow center; 11b: clear yellow; 11c: gold and pink; 11d: soft pink; 11e: lavender (tropical); 11f: burgundy red; 11g: deep pink)

12. 5 Siberian iris

A. 24 money plants

Numerical keys denote perennials; letter keys denote annuals.

**Overall dimensions:**
16 x 5 feet
*bench:* 4 feet
*rose arbor:* 5 feet wide

Choose a level location in full sun. Lay out the shape of the pond with a garden hose or long, heavy rope. Excavate the pond to a depth of 18 to 24 inches. A shelf 8 inches below the water surface can be cut out to grow water irises or bog plants. Side walls should not exceed a slope of 33 degrees.

Remove all sharp rocks or roots in the soil, and add 2 to 3 inches of sand for padding. Check to see that the rim of the pond is level so that the water level will be even.

If you decide to use a pool liner, drape "fish grade" PVC waterproof, flexible sheets (32 mil. thick) over the pond, overlapping its edges 10 inches on each side. Place weights around the overlapping liner. Slowly fill the pond with water. The weight of the water will mold the liner snugly into place. As the pond fills, gradually remove the weights to allow the liner to move inward, keeping enough tension to prevent wrinkles. When the pool is completely full of water, check to make sure the water level is even. Trim the overlapping liner to 6 inches. Edge the perimeter of the pond with flat paving stone or sand to hide the liner.

You can plant the aquatic plants directly into a layer of soil on the pond floor, or, if you are using a liner, in containers. You may find containers to be the easier method, reaping better results. Hardy aquatics should be planted at least 2 weeks after the last frost. Tropical waterlilies must be planted when the mean water temperature is 70°F or greater. You should check with nurseries specializing in water plants for more local requirements.

Plant the sweet coltsfoot around the edge of the pond where its round leaves will reflect in the water, spreading up to 6 feet in width. The arrowhead should also be planted along the pond's edge. Ferns can be planted along the paths. Plant all iris according to plan and cultural requirements. Choose your preference of Siberian, Japanese or yellow water iris. Select either tender lily-of-the-Nile in blue or hardy daylilies in lemon yellow for another colorful planting alongside the pond. Tree peonies are to be planted behind the bench with rhododendrons and azaleas interplanted across the pond. Follow cultural instructions. On a wooden or metal trellis, 5 feet long on each wing and at least 2 feet wide and 6 feet high, plant wisteria in the middle, training it across the top.

Money plant can be planted under the arbor. If your garden is large enough, consider planting a graceful weeping willow or a Japanese flowering cherry tree. This garden design indicates a 5-foot-wide arch for 2 climbing roses, which planted on either side of the arch will provide a fragrant backdrop to the bench.

In Monet's gardens a pinkish-beige pea gravel is used for the paths. This is clean and requires little maintenance, and its color is warm and preferable to grey gravel. Some gardeners may prefer a path of brick or stone. If you choose to do this, consider setting the bricks in sand so the drainage will be optimum and plants can be grown in the cracks between the bricks. A lawn path is a third alternative, but it requires more maintenance and will not endure many visitors.

96

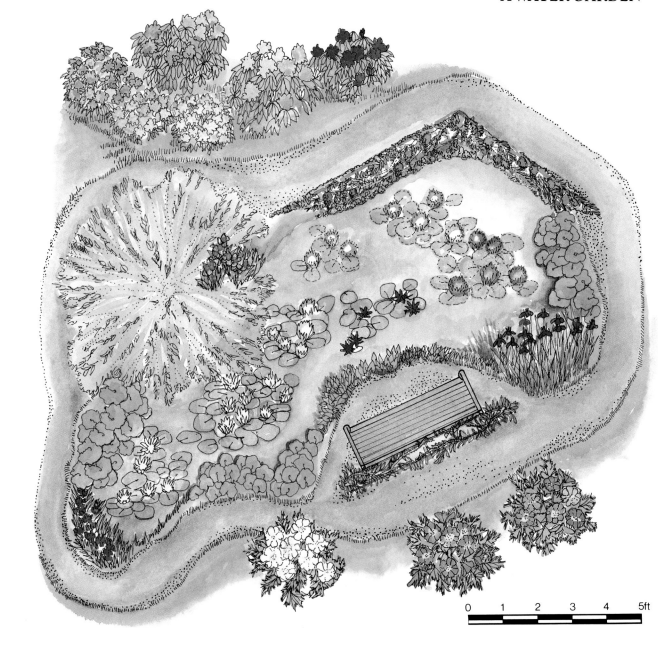

0  1  2  3  4  5ft

# ZONAL MAP

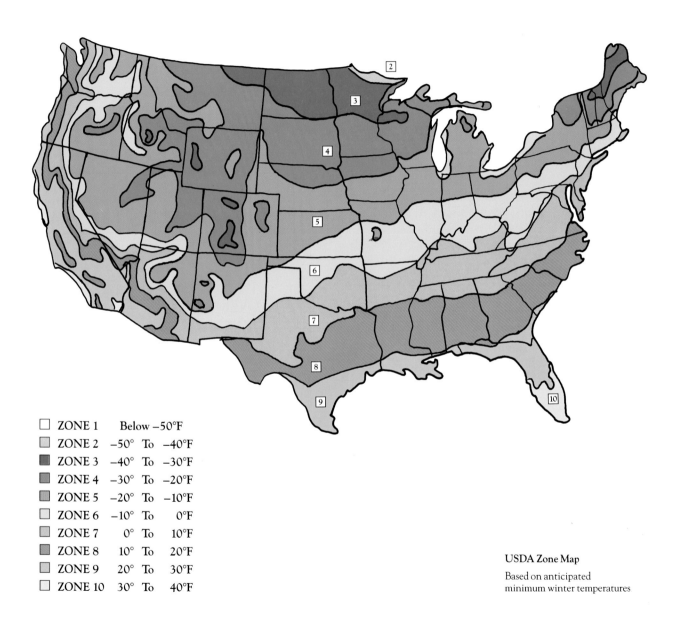

☐ ZONE 1    Below −50°F
☐ ZONE 2    −50°  To  −40°F
■ ZONE 3    −40°  To  −30°F
■ ZONE 4    −30°  To  −20°F
■ ZONE 5    −20°  To  −10°F
☐ ZONE 6    −10°  To    0°F
☐ ZONE 7      0°  To   10°F
■ ZONE 8     10°  To   20°F
☐ ZONE 9     20°  To   30°F
☐ ZONE 10    30°  To   40°F

**USDA Zone Map**

Based on anticipated
minimum winter temperatures

# PLANT CULTIVATION

**ARROWHEAD** *Sagittaria*
There are several very good varieties of this hardy waterside perennial with distinct arrow-shaped leaves. Height ranges from 1 to 3 feet, depending on kind. All have handsome, classic white flowers that bloom all summer. Plant tubers after the last frost in early spring or as late as June in an area that gets full sun. Push the tubers 2 to 3 inches into mud along a pond bank; they can be covered with up to 18 inches of water. Zones 4–9.

**ASTER**

Perennials in the daisy family, easy to grow in a sunny spot. Plants range in height from 6-inch-high mounded varieties to bushy ones 6 feet tall. Most asters bloom abundantly in summer and fall providing rich shades of deep purple, bright blue-violet and ruby-crimson. They also come in soft blues, lavender, pink and pure white for light airy spots in the summer garden. Divide and plant clumps in late fall or early spring, using vigorous outside growth; discard the unproductive centers of the plant. Asters will respond with more flowers if they are planted in rich soil and receive regular water.

*Aster Frikartii* ('Wonder of Stafa'). This outstanding hybrid grows about 2 feet tall; profusely covered with lavender-blue flowers from May to October. Zones 6–9.

*Aster novae-angliae* x *A. novi-belgii*. Crosses between these two 3- to 4-foot perennials have produced a large number of hybrids popularly known as MICHAELMAS DAISIES. Well-branched plants carry large clusters of flowers in white, pink, rose, red and shades of blue, violet and purple. Zones 6–9.

**AUBRIETA** *Aubrieta deltoidia*
This perennial grows in compact mounds 2 to 6 inches high, 12 to 18 inches across in full sun. Small grey-green leaves are covered with tiny pink, lavender or violet flowers in April and May; aubrieta's foliage provides main interest at other times of the year. Plant in spring by seeds or transplants; will tolerate semi-dry gardens when established. Monet used violet effectively in edgings along long flower borders. Hardy in Zones 4–8.

**AZALEA** (see RHODODENDRON)

**BAMBOO** *Phyllostachys* 99
Actually a giant grass with large, woody stems which lives for many years. Running, underground stems grow rapidly, sending up vertical shoots, creating large groves. There are hardy and tropical varieties; Monet grew many varieties of bamboo, but he favored *P. nigra* for its violet-black streaks. Green stems generally turn black in the second year. Plant in rich soil with organic amendments in a site where summer heat or winter cold is avoided. Mature culms will send up new shoots and grow to mature height in one month. Size depends on variety, but all are evergreen and can adjust to full or partial sun after they are established. Some summer water is beneficial. Zones 8–10; some species are also hardy in Zones 5–7.

**CHERRY TREE**
**(JAPANESE FLOWERING CHERRY)** *Prunus serrulata*

There are many varieties of these beautiful spring-blooming trees. Heights range from 20 to 40 feet. All require full sun and light, fast draining soil (not clay); can tolerate dry spells but prefer moderate summer water. The best times to transplant are autumn or early spring. Most varieties have pink blossoms, although white-flowering ones are also available. Shapes vary from the tall, narrow columnar *P.s.* 'Amanogawa' to the gracefully weeping *P.s.* 'Pendula'. Locate flowering cherries in your garden according to their growth habit. Zones 5–8.

**COTTAGE PINK** *Dianthus plumarius*
Perennial. Charming, old-fashioned edging or border plant with silver-blue loosely matted grasslike foliage. Monet edged his raised rose beds with cottage pinks. Dainty carnation-like flowers with 10- to 18-inch stems are single or double in pink, rose or white with dark centers or pink edging. Flowers have an unforgettable spicy fragrance and are perfect for small bouquets. Blooms from June to October; thrives in full sun and light, well-drained soil. Plant in autumn or spring 10 to 12 inches apart. Avoid over-watering and cut spent flowers regularly. Zones 3–8.

## DAHLIA

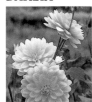

Perennials grown from tuberous roots that resemble sweet potatoes; also grown from seed. Flowers come in a tremendous range of size, color and flower shape. Monet preferred cactus dahlias with their simple, fluted petals 3 to 12 inches across. Some of his favorite dahlia colors were crimson edged in gold, lilac, and white with pink and yellow. Monet tried new varieties from seed. After danger of frost has passed, plant tubers in full sun in soil rich with organic matter when the ground has warmed up. Plant in holes 1 foot deep and 3 feet apart. Stake plants, taking care not to injure tubers. Water deeply and keep moist. Tubers may be wintered over in the ground in Zones 9–10 (8 with protection); elsewhere, dig up before freeze and store tubers in frost-free place.

## DAYLILY                                                      *Hemerocallis*

Perennial with tuberous roots growing in large, spreading clumps with arching, sword-shaped deciduous or evergreen leaves. Spectacular, lily-like flowers in a wide range of colors, including cream, yellow, coral, pink, salmon, bronze and red. These vigorous, pest-free plants grow in almost any kind of soil in full sun or partial shade, but flowers will last longer given afternoon shade. Water deeply while blooming, fertilize in spring and mid-summer, and divide and plant in early spring or late fall. Zones 4–9.

## DELPHINIUM

Perennial with spectacular flower spikes atop stems that sometimes reach up to 8 feet on modern hybrids. Most gardeners seem to favor delphiniums in shades of blue, from pale sky-blue to deep violet-blue, but delphiniums are also available in pink, lavender and white. The older, dark purple-flowered candle delphinium (*D. elatum*) is probably the species Monet grew in his borders. In mild, cooler climates, Pacific Strain delphinium hybrids will bloom once in spring, die back, and bloom again in early fall with a smaller spike if plants are fertilized. Delphiniums can be grown from seed, nursery transplants, or from rooted divisions of clumps planted in spring or fall. Choose a place that receives full sun (or light shade in hot climates), and provide deep water when the plants are developing and flowering. Hardy in Zones 3–7, but treat as a hardy spring annual in Zones 8–10.

## DUTCH IRIS (see IRIS)

## FERNS

A large group of perennial plants grown for their light, airy, woodland feeling in the garden. Ferns are easy to grow if given light or partial shade and cool, moist conditions in a soil rich in humus. It is best to plant them in spring, after all frost, or in autumn; avoid planting in hot weather. Sizes range from 6 inches to over 6 feet. When selecting ferns for your garden, check with nurseries or with specialists who can recommend those kinds best suited to your climate and growing conditions. Following are several hardy ferns:

LADY FERN (*Athyrium filix-femina*). Grows 3 feet tall, with finely divided fronds. Looks delicate, but will tolerate fairly dry soils. Zones 3–8.

JAPANESE SWORD FERN (*Dryopteris erythrosora*). Grows 18 to 24 inches tall, with new bronze growth that matures to dark green, then turns bronze again in autumn. Zones 5–9.

OSTRICH FERN (*Matteuccia struthiopteris*). Reaches 5 to 6 feet in height. Needs half to full shade in rich, moderately moist soil. Zones 5–9.

SHIELD FERN (*Polystichum braunii*). Green, leathery, spine-tipped fronds are 18 to 24 inches long. Zones 6–8.

## FORGET-ME-NOT                                     *Myosotis scorpioides*

Perennial often used as an annual. Known for its rich blue tiny flowers with yellow centers; blooms freely from spring through summer. Effective massed together planted over tulips, woven into perennial borders or left to naturalize in woodlands where it often self sows. Flowers most profusely in partial shade with ample water. Annuals must be planted in spring; perennials in autumn or spring. *M. sylvatica*, often sold as *M. alpestris*, ('Indigo compacta') is a biennial which can be planted over a bulb bed in the autumn and winter over in most climates. These tiny, clear blue, white-eyed flowers bloom and reseed for a long season beginning in late winter or early spring until the weather is hot. Forget-me-nots also come in pink or white. Zones 3–8.

## FOXGLOVE                                              *Digitalis purpurea*

A favorite, old-fashioned biennial or perennial for shaded or partially shaded borders and woodland type settings. Magnificent flower spikes with large bell-shaped flowers attractively spotted in the throat reach minimum height of 4 feet. Colors range from white and shell pink to deep rose, lavender and purple. Blooms in May through September in full sun to light shade

in moist, rich soil. Plant by seed in spring or set out plants in fall for spring bloom. Foxglove freely self-seeds. Zones 4–9.

## GERANIUM (COMMON)           *Pelargonium xhortorum*

A highly favored, widely used tender perennial, often used as an annual in cold climates. Monet enjoyed combining red and pink single-flowered geraniums in a bed bordered with old-fashioned pinks. Popular for containers, window boxes and flower beds; easily propagated by cuttings; can be wintered over as a houseplant. Plants grow 14 to 20 inches high. Round, dark green leaves have velvety texture. Colors include white, pink, salmon and red. Plant in full sun in spring after all frost in rich, well-drained soil. For best bloom, water and fertilize regularly and remove spent flowers and leaves. All zones as a summer bedding plant or houseplant; Zones 9–10 as a shrubby perennial.

## HOLLYHOCK           *Alcea rosea (Althaea rosea)*

Monet preferred the old-time, single perennial variety that can reach 9 feet. Colors include white, yellow, coral, pink, red and crimson. Blooms in summer if planted the preceding autumn in sun. Give regular watering, but avoid wetting foliage, which can spread rust. Zones 3–9.

## IRIS

BEARDED IRIS (FLEUR-DE-LIS). This fragrant perennial, old-fashioned bearded iris (formerly called German iris, although not native to Germany) has 9-inch-tall lavender-purple flowers on 2- to 3-foot stems from late spring to early summer. The almost indestructible rhizomes form dense clumps that choke out weeds and must be lifted and divided every 3 to 4 years. Monet planted thousands of this one kind of iris in 3-foot-wide monochrome borders with striking results. Plant rhizomes in early spring or autumn in rich, well-drained soil in full sun. Provide ample water, especially while in bloom. Zones 4–9.

DUTCH IRIS. Slender, delicate leaf-shaped flowers, 3 to 4 inches across, top stems 18 to 24 inches tall. Colors include white, yellow and bronze, as well as blue, mauve and purple. Plant the small bulbs in autumn 3 to 4 inches deep in sun. Provide regular water. Dutch iris bloom earlier than most bearded iris, in late spring or early summer. Excellent for container culture and cutting. 'Wedgewood', light, clear blue with a yellow blotch, was Monet's favorite variety. Zones 5–8.

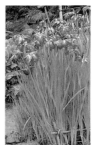

JAPANESE IRIS (*Iris kaempferi*). Spectacular irises with flowers 6 to 9 inches across with wide, reflexed, heavily veined petals appearing in June and July. Colors range from pure white to lavender and blue-violet. Best grown in moist, humus-rich, acid soil in full sun. Ideal for planting in or near water up to 6 inches deep. Plant rhizomes in early spring or autumn and mulch in winter. Good cut flower. Zones 5–9.

SIBERIAN IRIS (*Iris siberica*). Graceful flowers shaped like Dutch iris bloom on 2- to 3-foot stems after bearded irises have faded. Colors include pale and deep blue, purple, red-violet and white. Can be grown in perennial borders in full sun if given moist soil high in humus. Plant rhizomes in spring or from divisions in September through October; well-established clumps bloom best. Zones 3–9.

YELLOW WATER IRIS (*Iris pseudacorus*). This hardy perennial iris grows 5 feet tall with spectacular 3-inch bright yellow flowers in May and June on stems 6 to 7 feet tall. Thrives in shallow water (to 18 inches deep); can also be planted on an island in a pond or along water's edge. Plant rhizomes in spring or fall. Full sun to light shade. Zones 3–9.

## JAPANESE FLOWERING CHERRY (see CHERRY)

## JAPANESE IRIS (see IRIS)

## JAPANESE TREE LILAC (see LILAC)

## LAMB'S EARS           *Stachys byzantina*

Hardy perennial, grown for its soft, thick, silvery downy leaves on spreading 18-inch stems. A very attractive foliage plant; blends exceptionally well with blue, lavender and dusty pink; also makes wonderful contrast with red. Purple flowers in summer can be removed to preserve the foliage. Plant after all frost in spring in well-drained soil. Sun to light shade, light summer water. Cut back frost- or water-damaged leaves in spring. Zones 4–9.

## LEOPARD'S BANE           *Doronicum cordatum (D. caucasicum)*

This perennial has bright yellow, daisy-like flowers that bloom in early spring on long stems. It is stunning planted with blue forget-me-nots and violas or purple lilac with lavender tulips, as did Monet. The variety 'magnificum' is a strong plant with big-

ger flowers. Good cut flower. Plant in spring after frost or in autumn. Grow in filtered light in good soil and give average water. Zones 3–8.

### LILAC (COMMON)          *Syringa vulgaris*
Deciduous shrubs can eventually mature to 20 feet wide and tall. Best known and loved for their 10-inch-long clusters of lavender, very fragrant flowers. Colors include white and pinkish to bluish violet. French hybrids have larger clusters of single or double flowers in many colors; bloom slightly later than common lilac. Lilacs need cold winters, sunny location and alkaline soil; they bloom in May or June. Plant shrubs in autumn or early spring, adding lime to acid soils when planting; provide good drainage. Provide regular summer water but cut back water in August in mild winter areas to promote bloom. Water deeply while growing and in flower. Zones 3–8 (check variety).

JAPANESE TREE LILAC (*Syringa reticulata, S. japonica*). Large, deciduous shrub easy to train as single-trunk, 30-foot tree. Large (5-inch-long) heart-shaped leaves. Showy white or lavender flower clusters 12 inches long bloom in late spring to early summer; not very fragrant. Plant in autumn or early spring in rich, well-drained soil in half sun. Can tolerate some dry spells in summer if the weather is cool. Blooms better with cold winter dormancy. Zones 3–8.

### LILY-OF-THE-NILE          *Agapanthus orientalis*

Evergreen, tender perennial related to amaryllis with as many as 100 clear blue flowers in clusters on one 4- to 5-foot stem. Straplike leaves grow in clumps. Thrives in loamy soil with ample water during growing season but will adapt to heavy soil and drought when established. Can bloom from spring into autumn in favorable conditions. Adaptable to sun or shade, but must be lifted and stored in cold-winter areas. Excellent container plant, beautiful by water. Monet grew it by his pond. *Agapanthus* 'Peter Pan' is an outstanding dwarf variety with exceptional numbers of flowers. Zones 7–10 (outside).

### LUPINE          *Lupinus polyphyllus*
Spectacular perennials, 1½ to 4 feet tall, with dense flower spikes, 6 to 24 inches long. Deeply divided, rich green leaves. Flowers shaped like sweet peas come in many shades of blue, pink, red, purple and deep violet, with some striking bicolors.

Plant in early spring (or established plants in fall) in full sun to light shade. Mulch to keep cool; give summer water and cut to the ground after spring flowering to induce second bloom. Zones 4–7.

### MICHAELMAS DAISY (see ASTER)

### MONEY PLANT          *Lunaria annua*
Biennial. Lavender-purple flowers in May and June grow profusely in shade and filtered light. Flat disc-like seedpods mature into handsome transparent, silvery white. Attractive winter decorations, for a moon garden to reflect moonlight, and for dry flower arrangements. Height is 2 to 3 feet. Plant by seed in spring or autumn; can grow in poor soil; benefits from some water while in bloom. Money plant can reseed and look wild. Zones 4–8.

### NASTURTIUM          *Tropaeolum majus*

A perennial in mild climates; otherwise used as an annual. Plant by seed after frost in average soil. The distinctive 2- to 3-inch round leaves and long-spurred flowers have a refreshing peppery fragrance and a flavor similar to that of watercress. Both can be used in salads. Flowers range from creamy white to yellow, gold, orange, red and maroon. Easy to grow in well-drained soil and a sunny location where summers don't get dry and hot. Plant by seed after frost in average to poor soil. The trailing vines can creep up to 8 feet. Blooms all summer and fall until killed by frost. Adaptable, but benefits from some summer water. Perennial: Zones 8–9; annual: all other zones.

### ORIENTAL POPPY          *Papaver orientale*
Monet planted these 4-foot-high perennials in beds on his lawns in great profusion, using varieties ranging in color from bright vermilion with bold, contrasting black centers, to shades of striking bluish-grey, pink and coral. Flowers are 5 to 8 inches wide. Plants die back in midsummer and new growth appears in early fall; interplanting poppies with late summer-blooming plants helps to hide their fading foliage. Plant in early spring or fall in ordinary soil with good drainage. Give light watering and feeding until established. Zones 3–8.

### PANSY      *Viola cornuta, V. wittrockiana (V. tricolor hortensis)*
Annual with a wide range of colorful 2- to 3-inch-wide flowers in white, blue, deep red, rose, yellow, apricot, purple and bicol-

ors. Centers are typically blotched or striped with contrasting color creating whimsical faces enjoyed by children. Plant by seed in July or August in full sun to partial shade in rich, moist soil. Transplant seedlings into cold frame for winter. Set plants out in spring; they can tolerate frost. In mild winters set out nursery plants in fall for winter and spring flowers. Hot weather will make pansies leggy. Pinch plants and remove spent blooms to extend flowering period. Zones 3–9.

## PEONY (TREE PEONY) *Paeonia*
Deciduous shrubs with irregular branching habit 3 to 6 feet tall need full sun. Leaves are large, deeply divided, blue-green to bronzy green. Flowers are very large and elegant with silky texture, up to 12 inches across. Monet preferred the single Japanese types to the heavy double European kinds. Many have the fragrance of old-fashioned roses. Colors include white, yellow, pink, red, lavender and purple. Very hardy to cold, blooming in early to late spring. Water regularly in summer. Plant deep in the fall in a well-dug hole enriched with organic matter (avoid using manure near roots). Zones 4–8.

## PHLOX (SUMMER PHLOX) *Phlox paniculata*
This hardy perennial blooms profusely from midsummer to fall in full sun or light shade. The old-fashioned, sweetly scented flower reaches 24 to 30 inches in height. Mulch around the plants to keep roots cool where summers are hot. Plant transplants in spring or by seed in fall; divide plants every few years, planting young shoots on outside of clumps in spring. Give regular water and average garden soil. Blooms in pure white, soft pink, red and sky-blue. Zones 3–9.

## PRIMROSE
(often called ENGLISH PRIMROSE) *Primula polyantha*
Perennial used as an annual in hot climates. Bright green rosettes of leaves resemble small Romaine lettuce leaves. Charming 1-inch-wide flowers in bouquet-type clusters come in all primary colors as well as white, orange and purple. Bloom from late winter through spring in moist, shady garden with rich soil. In mild winters, transplants can be set out in fall for winter and spring flowers; in cold areas set out when ground thaws in spring. Zones 5–8.

## RHODODENDRON (AZALEA)

DECIDUOUS AZALEAS. Exceptionally hardy types include the Exbury and Mollis hybrids, growing 3 to 6 feet high. Colors include red, orange, pink and white. Some are very fragrant, and their autumn foliage turns to brilliant orange, red and purple. Plant shrubs in early spring while in flower (to see exact flora color) in deep holes mixed with peat moss and leaf mold. All azaleas enjoy moist acid soil with excellent drainage; protect from summer sun. Zones 3–8.

EVERGREEN AZALEAS. Require moisture in the summer, filtered light and acid soil. White, pink and lavender flowers in May and June; Monet preferred shrimp red, pink and pure white azaleas. Depending on variety, evergreen azaleas reach heights of 3 to 6 feet with equal spread. Plant in spring to check flower color. Zones 6–9.

## ROSE *Rosa*

Until the turn of the century, most roses were grown in shades of white, pink, mauve and red. In the early 1900s, the first hybrid tea roses of rich, pure deep yellow were available. Soon after, breeders could produce more vibrant colors like fiery copper and burning reds. Monet loved to grow new varieties with these brilliant shades of color, but he always favored the simple, single flower roses in shades of pink, yellow, salmon and red. Rambling roses like 'Belle Vichysoisse', 21 to 24 feet long, wound around tree trunks at Giverny, blooming once a season with a profusion of small, scented flowers in long clusters. 'Mermaid', a single-flowered, soft yellow rose, blooms for a long period in mid-season; it was so favored by Monet that he grew it on a trellis under his second-story bedroom. Special iron trellises arching over the Grande Allée provided support for climbing roses in many colors. Ten-foot, triangle-shaped pillars were garlanded with roses; umbrella-shaped structures supported standards topped with a miniature climbing rose previously grafted to an understock stem, and trained to shower gracefully downward.

Choose a site for your roses with at least 6 hours of sun each day, preferably morning light, which is cooler than afternoon sun. Locate roses away from large trees and shrubs as they will compete for nutrients, water and light. Use a raised bed for the

excellent drainage essential for growing roses. You will have more varieties to choose from and less expense if you plant from bare root stocks when the ground thaws in the spring.

Dig a hole at least 30 inches wide that is deep enough to accommodate the roots. Add rich organic amendments to native soil such as compost, leaf mold or aged cow manure. Fill the hole with mixed rich soil. If you live in a climate where the ground freezes solid in winter, make sure the bud union (where the stems have been grafted to the root stock) is 1 inch below the soil level; in milder climates, it should be above the soil level. Pat the soil around the roots firmly. Make a round basin with mounded soil around the rose. Fill with water and allow the rose to settle in. Adjust rose if sinking has occurred.

Size and blooming times vary with variety, but roses generally bloom in summer with some late spring and early fall flowers. Feed established roses 3 to 4 weeks after planting (bare root roses should be fed after leaves with 5 leaflets appear). Mulch roses with 4 to 5 inches of organic material, bark, pine needles, straw, aged manure or compost. Zones 4–10 (check particular variety for hardiness).

**SAGE** ("BLUE BEDDER" and "VICTORIA") *Salvia farinacea*
Tender perennial used as an annual where winters are severe. Fast-growing to 3 feet with grey-green foliage. Velvety spikes of violet-blue flowers resembling English lavender rise above the plant. Excellent cut flowers, fresh or dried. Plant in full sun in spring after last frost in average garden soil with good drainage. Will bloom all summer and into the autumn; can tolerate drought when established. Zones 4–8.

**SIBERIAN IRIS** (see IRIS)

**SQUILL** (BLUEBELL) *Scilla bifolia, S. tubergeniana*
Blooms very early at the same time as snowdrops, Christmas roses and winter jasmine in Monet's garden. Blue starlike flowers appear on clusters of stems 4 to 8 inches long. Plant these small, early-blooming bulbs in the fall with good drainage. Most effective planted in informal drifts 2 to 3 inches deep, 3 to 4 inches apart in full sun. *S. peruviana* is a better choice for warmer climates. Blooms May to June. Zones 4–9.

**SUNFLOWER** *Helianthus multiflorus*
A hardy perennial that grows 3 to 5 feet high—a splendid plant for late summer and autumn bloom. It produces hundreds of long-lasting, cheerful, yellow-gold daisy-like flowers, excellent for cutting. Plant in spring or fall in full light and well-drained soil. Requires moderate water while in growth period. Zones 3–9.

**SWEET COLTSFOOT** *Petasites japonicus*
This creeping, hardy herbaceous perennial is dormant in winter. It is an invaluable plant for cool, shady sites near water's edge where a dramatic large-leafed ground cover or accent plant is desired. The distinctive heartshape leaves develop to 16 inches wide with a white, woolly underside and dull, dark green surface. Petasites are about 1 foot in height and can spread up to 6 feet. The early spring flowers are treasured by flower arrangers; the stem is grown for a vegetable in Japan. Plant in spring or fall in the moist soil along the edge of water. Zones 4–9.

**TREE PEONY** (see PEONY)

**TULIP** *Tulipa*
Monet grew tulips of every color and hue to create striking color combinations. His favorites included:

DARWIN TULIPS. Large oval flowers on stately stems up to 2½ feet tall, with a color range from white to an almost pure black, with all shades but blue in between. These tulips give the best show for display gardens.

PARROT TULIPS. Fringed petals with twisted shapes distinguish this unusual tulip, excellent for cutting.

RETROFLEX TULIPS. A group noted for its reflexed petals, much like lilies. Monet preferred a clear yellow.

REMBRANDT TULIPS. Distinguished by striped and mottled petals of contrasting colors.

Plant tulips in full sun in autumn 9 to 10 inches deep instead of the usual 4 to 6 inches to prolong blooming life over several seasons. The deeply planted bulbs will allow for overplantings of annuals and shallow rooted perennials without disturbing the bulbs. Plant in well draining, friable soil with bonemeal. Zones 3–9; tulips will bloom from late March to mid May in Zone 6;

104

early and late blooming varieties will bloom at different times in different zones. Don't let the bulbs dry out while in bloom.

### WALLFLOWER                                    *Cheiranthus cheiri*
Favorite old-time cottage garden perennial or biennial with sweetly scented flowers 2 feet tall. Molten colors in rich shades of yellow, gold, orange, brown, coral, salmon and burgundy are effective in large masses. Blooming in early spring, wallflowers are logical companions for tulips, Dutch iris, columbine or lilacs. Locate in light shade to full sun in moist, well-drained soil. Sow seed in spring for bloom the next year, or transplant hardy seedlings in fall or early spring. Zones 6–10.

### WATERLILY                                            *Nymphaea*

There are hardy and tropical waterlilies. They both require at least 5 hours of sun, but do best with a full day of sunlight. Both kinds range in size from 6-inch miniature to large ones over 4 feet across.

Hardy varieties can be grown almost everywhere. Flowers last 5 consecutive days in warm, sunny weather and bloom continuously through summer until first frost. Colors range from pure white to yellow, coral, pink, orange, rose-red and burgundy. Zones 3–10.

Tropical waterlilies come in extraordinary colors, including amethyst blue, deep plum, lavender and sunset blends of yellow, pink and apricot. Tropicals must be planted after warm weather has settled in. Set plants in tubs of rich, heavy soil; take the tubs out of the water in the winter. These fragrant flowers will continue to bloom after frost has put hardy waterlilies to sleep. Zones 3–10 (if used as annuals or stored over winter).

### WEEPING WILLOW                                *Salix babylonica*
Deciduous trees with graceful, pendulous, golden, whip-like branches mature to 30 to 50 feet with equal spread and lovely weeping habit. Long, narrow, bright green leaves emerge in very early spring.

Willows require plenty of water and have invasive roots; best planted next to a pond or stream; can tolerate poor soil and poor drainage. Plant these fast growing trees in spring or fall in a site that receives full sun. Monet used willows ideally alongside his pond where their graceful branches touched the water and their roots held the bank. Zones 3–9.

### WISTERIA
Deciduous woody vines, usually very long-lived, with exceptionally beautiful flowers. Can be trained as a tree, shrub or vine. Monet used wisteria in all forms: as a vine on the bridge and in front of his house, as a small tree by the pond, and throughout the flower garden. Plant from cuttings or grafted root stock in the spring; provide good drainage and ample water and fertilizer while plants are young. Mature plants will bloom better with less food and water in full sun but will adjust to filtered light. Zones 5–9.

CHINESE WISTERIA (*W. sinensis*). Flower clusters shorter (to 12 inches) than Japanese wisteria, but more showy because flowers bloom before leaves and earlier than Japanese wisteria.

JAPANESE WISTERIA (*W. floribunda*). Lavender to blue fragrant flowers bloom in 18-inch-long clusters; leaves divided into many leaflets. Prolong blooming season by planting with later-flowering Chinese wisteria. A white variety ('Alba') is available.

Monet combined both varieties of wisteria for extended blooming time. Mauve wisteria bloomed in profusion on the top trellis of the Japanese bridge, and white wisteria graced the lower spans of the bridge providing breathtaking reflections in the water below.

### YELLOW WATER IRIS (see IRIS)

106

The following list of plants used in Monet's original gardens has been gathered from several sources: Jean-Marie Toulgouat's garden plan, which appeared in Claire Joyes' book *Monet at Giverny*; an in depth article by botanist and garden writer Georges Truffaut, who visited Monet at Giverny and wrote "The Garden of a Great Painter" in 1924 in the periodical *Jardinage*; an 1891 article by novelist, art critic and fellow gardener Octave Mirbeau, Monet's close friend, entitled "Claude Monet" in the periodical *L'Art Dans Les Deux Mondes*; and my own study of old photographs and talks with plant specialists. Unfortunately, for some of these plants I have not included a specific species because my research on them proved to be inconclusive. Occasionally I have chosen a likely variety that Monet may have used according to the literary description and growing conditions required. However, when you choose plants for your garden, it is not as important to match Monet's specific species of plant as it is to use one that may be similar, but will grow and thrive in your particular garden environment.

Some plants Monet used in his garden, such as plumbago, were very rare in his day, and yet they may be easily obtained today. On the other hand, today it may be difficult to find many old-fashioned single varieties of flowers and unhybridized plants. The sources list on page 112 provides the names and addresses of suppliers who carry these more unusual plants.

## THE CLOS NORMAND GARDEN

**Spring Bulbs:**
*Galanthus nivalis.* Common snowdrop
*Hyancinthus orientalis.* Common or Dutch hyacinth
IRIS. Dutch iris (so-called because first hybridized by Dutch growers)
NARCISSUS. Daffodil. Monet preferred trumpet (large-cupped) varieties such as 'King Alfred' and shallow-cupped varieties such as 'poet's narcissus' (also called 'pheasant's eye').
*Scilla bifolia, S. tubergeniana.* Squill, bluebell
*Tulipa.* Tulip. Among the different tulips grown by Monet were Darwin, parrot, retroflex and Rembrandt.

**Summer/Fall Bulbs:**
CANNA
DAHLIA. Monet especially liked the cactus and singled-flowered varieties.
GLADIOLUS. Varieties with smaller flowers and looser, more informal growth habit, such as *G. callianthus (Acidanthera bicolor)*, pleased Monet.
*Lilium japonicum.* Japanese lily. Two of the most important Japanese species are *L. auratum* and *L. speciosum.*

**Spring Perennials:**
*Aquilegia vulgaris.* European columbine
*Aubrieta deltoidea.* Monet used this extensively as an edging plant along long flower borders.
*Cheiranthus cheiri.* Wallflower
*Doronicum caucasicum.* Leopard's Bane
*Eschscholtzia californica.* California poppy
*Helleborus niger.* Christmas rose.
IRIS. Tall bearded iris (formerly known as *I. germanica*, or 'German iris')
*Paeonia.* Peony (both herbaceous and tree peonies)
*Papaver orientale.* Oriental poppy

*Penstemon gloxinioides.* Border penstemon, garden penstemon
*Primula polyantha.* Polyanthus or English primrose
*Viola cornuta.* Tufted pansy

**Summer Perennials:**
*Aconitum napellus.* Garden monkshood
*Alcea rosea* (formerly called *Althaea rosea*). Hollyhock (single only)
ANEMONE hybrids. Japanese anemone, windflower (white only)
*Aster frikartii.*
*Aster novi-belgii.* Hybrid (with *A. novae-angliae*). Michaelmas daisy
*Campanula medium.* Canterbury bell, cup-and-saucer
DELPHINIUM.
*Dianthus plumarius.* Cottage pink
*Digitalis plumarius.* Foxglove
*Echinacea purpurea (Rudbeckia purpurea).* Purple cornflower
*Eryngium alpinum.* Blue thistle
*Helianthus multiflorus.* Sunflower
*Heliopsis scabra.* The 'Light of Loddon' variety grown by Monet may no longer be available.
*Hemerocallis.* Daylily
*Lavandula dentala.* French lavender
*Oenothera.* Evening primrose
*Pelargonium domesticum.* Martha Washington geranium
*Pelargonium hortorum.* Common or garden geranium
*Perovskia atriplicifolia.* Russian sage
*Phlox paniculata.* Summer phlox
*Saxifaga.* Saxifage
*Solidago canadensis.* Goldenrod
*Verbascum.* Mullein

**Summer Annuals:**
*Antirrhinum majus.* Snapdragon
*Calendula officinalis.* Pot marigold
*Callistephus chinensis.* China aster
*Chrysanthemum frutescens.* Paris daisy or Marguerite
*Chrysanthemum maximum.* Shasta daisy
*Helianthus annuus.* Common sunflower
*Lathyrus odoratus.* Sweet pea
*Matthiola icana.* Stock
*Reseda odorata.* Mignonette
*Tropaeolum majus.* Nasturtium (trailing types used along paths)

**Shrubs:**
*Ceratostigma plumbaginoides.* Dwarf plumbago
*Hydrangea macrophylla.* Big-leaf hydrangea, garden hydrangea
*Hypericum calycinum.* Creeping St. Johnswort
*Jasminium nudiflorum.* Winter jasmine
*Plumbago auricula.* Cape plumbago
*Rosa.* Climbing roses, pillar roses, shrub roses, standard roses
*Syringa reticulata.* Japanese tree lilac
*Syringa vulgaris.* Common lilac
VIBURNUM

**Vines:**
*Aristolochia durior.* Dutchman's pipe
*Clematis montana.* Anemone clematis
*Parthenocissus quinquefolia.* Virginia creeper
*Passiflora caerula.* Blue crown passion flower
*Wisteria floribunda.* Japanese wisteria
*Wisteria sinensis.* Chinese wisteria

**Trees:**
*Acer macrophyllum.* Big-leaf maple
*Acer palmatum.* Japanese maple
*Aesculus carnea.* Red horsechestnut
*Liquidambar.* Sweet gum
*Malus floribunda.* Japanese flowering crabapple
*Platanus.* Plane tree, sycamore
*Prunus serrulata.* Japanese flowering cherry
*Tilia europaea.* Linden (small-leaf European linden or lime tree)

**THE WATER GARDEN**

**Perennials:**
*Agapanthus orientalis.* Lily-of-the-Nile
*Cortaderia selloana.* Pampas grass
*Geum rivale.* Water avens
GUNNERA MANICATA
*Hemorocallis.* Daylily
*Inula ensifolia.* Yellow daisy
*Iris kaempferi.* Japanese iris
*Iris pseudocorus.* Yellow flag iris
*Iris siberica.* Siberian iris
*Nymphaea.* Waterlilies (both hardy and tropical)
*Petasites japonicus.* Sweet coltsfoot

107

*Polygonatum.* Solomon's seal
*Salsify.* Oyster plant
*Thalictrum aquilegifolium.* Meadow rue

**Shrubs:**
*Berberis* (possibly *B. thunbergii*). Japanese barberry
*Chaenomeles.* Flowering quince
FERNS (many species)
*Ilex aquifolium.* English holly
*Kalmia.* Mountain laurel
*Paeonia.* Japanese tree peonies
*Phyllostachus.* Bamboo (*P. nigra*, black bamboo, and many other species)
RHODODENDRON (including deciduous and evergreen AZALEAS)

*Rhus typhina.* Staghorn sumac
*Rosa.* Climbing roses and standard roses
*Rubus idaeus.* Framboise
*Spiraea japonica.* Japanese spiraea

**Trees:**
*Alnus.* Alder
*Fagus sylvatica* ('Atropunicea'). Copper beech
*Fraxinus excelsior.* European ash
*Fraxinus ornus.* Flowering ash
*Gingko biloba.* Maidenhair tree
*Laburnum anagyroides.* Goldenchain tree
*Populus nigra.* Lombardy poplar
*Populus tremuloides.* Quaking aspen
*Salix alba tristis.* Weeping willow

# A CHRONOLOGY OF THE GARDENS

**1840** Monet born in Paris, November 14

**1859** Monet moves from his family home in Le Havre to study painting in Paris.

**1867** Monet and Camille Doncreux have their first son, Jean. Severe financial problems.

**1870** Monet and Camille marry, year of the Franco-Prussian War.

**1876** Monet meets Ernest and Alice Hoschedé and receives important commission.

**1877** Ernest Hoschedé goes bankrupt and leaves the country.

**1878** Sale of Hoschedé estate; Alice and her six children move to the village of Vétheuil to live with Monet family. Claude and Camille have second son, Michel.

**1879** Camille Monet dies of tuberculosis, and Alice Hoschedé takes charge of the eight children and household.

**1883** Monet rents the large pink house in Giverny. Alice Hoschedé, the eight children, three boats, household belongings and studio supplies are moved to Giverny.

**1890** Monet manages to buy the Giverny house for 22,000 FF. He paints locally. Builds his first greenhouse for orchids and other exotic plants.

**1891** Ernest Hoschedé dies and is buried in Giverny.

**1892** Monet and Alice Hoschedé marry. Monet hires his head gardener Felix Breuil and, soon after, five more gardeners to keep up the ever-growing gardens.

**1893** Monet creates the waterlily pond and gardens from the strip of land he buys across the road and railroad track, "Chemin du Roy."

**1895** Monet paints his first waterlily series.

**1901** The waterlily pond is redesigned with a modified shape.

**1908** Monet's sight begins to fail.

**1909** Alice Monet becomes very ill. Monet exhibits his new series of waterlily paintings.

**1910** During the winter, extensive storms cause the Seine to flood, putting the entire river valley underwater. Monet's gardens severely damaged.

**1911** Monet repairs his water garden and decides to enlarge the pond, adding the wisteria trellis to the Japanese footbridge. Alice Hoschedé Monet dies May 19; Monet is grief-stricken.

**1914** Monet's son, Jean, dies. Construction of the large barn-like studio (the Atelier aux Nymphéas) is begun to enable Monet to paint the large waterlily paintings, a gift for France. World War I begins.

**1916** The Atelier aux Nymphéas is finally completed after construction is delayed because of the war. Monet anxiously has the obtrusive building landscaped with Virginia creeper and other vines.

**1921** Monet suffers severe eye problems and discouragement.

**1923** At 83, Monet has an operation to remove his cataracts —a rather new procedure. His sight improves and he continues work on the large waterlily decorations.

**1926** Claude Monet dies on December 5 after completing his "Decorations des Nymphéas."

**1927** The magnificent waterlily series of 19 panels, each 6½ feet high and up to 20 feet long, are installed in two specially constructed oval-shaped rooms in the Orangerie Museum in Paris's Tuilleries Gardens.

**1927 to 1947** Blanche Hoschedé Monet takes loving care of the Monet house and gardens, keeping it protected during the occupation of Giverny during World War II.

**1947** Blanche Monet dies. The gardens are no longer maintained in the manner established by Monet.

**1947 to 1960** House and gardens under Michel Monet's (Claude's surviving son) supervision. A caretaker is employed to maintain the property.

**1960** The 82-year-old son, Michel Monet, dies, leaving the entire estate to France's Académie des Beaux-Arts. The roof of the main house is repaired; the paintings are transferred to the Musée Marmottan. For lack of funds and interest, the property and gardens fall into ruin.

**1977** Institut de France asks M. Gerald van der Kemp, curator of Versailles, to be the curator of the Monet legacy in Giverny.

**1977 to 1978** Seed money is raised from French and American sources, but renovation is slow. M. Gilbert Vahé, graduate of Ecole Nationale d'Horticulture, becomes head gardener. Mrs. Lila Acheson Wallace, founder of The Reader's Digest Foundation, donates over one million dollars. Major renovation begins on the gardens, pond and buildings.

**1978** Major art show entitled "Monet's Years at Giverny: Beyond Impressionism" is held at the Metropolitan Museum of Art. This show rekindles the love and interest Americans have for Monet's work.

**1979** Ambassador Walter Annenberg donates funds for a tunnel under the road dividing the gardens for visitors to safely walk from the flower garden to the waterlily pond. Money from American and French sources continues to support the many major and detailed aspects of restoration. Greenhouses and cold frames are constructed to raise all the thousands of annuals from seed.

**1980** The gardens open to the public for the first time.

**1981** Admirers of Monet and garden lovers flock by the thousands to Giverny from April 1 - October 30.

**1984** The Farm Project begins. An old stone farm opposite Monet's house is converted into a studio for housing artists and a tea room and shop to help support the gardens.

**1985** Elizabeth Murray works as the only woman gardener in Monet's gardens from April through October.

**1986** The studio, shop and tea house at the farm are completed.

**1988** The first three painters chosen from the Reader's Digest Artists at Giverny Program (administered by the College Art Association of America) come to Giverny.

**1990** The 10-year anniversary of the opening of Monet's gardens to the public.

# A VOCABULARY OF COLOR

**Chroma**   Strength of color. The chroma may vary from weak-greyish to strong, pure color. Other words for chroma: saturation, purity, brilliance, intensity.

**Complementary Colors**   On the color wheel, when placed side by side, each makes the other appear more intense.

**Contrast**   A distinct difference between two parts of the same color dimension, which may range from subtle to strong hues that are diametrically opposite each other.

**Cool Colors**   Blue, green and purple. These colors seem to recede.

**Cool Hues**   Hues associated with cool temperatures. Blue-green, blue, purple-blue and purple are cool hues; red-purple and green form the border between warm and cool hues.

**Dimension of Color**   A measurably visual quality of color. Each color has three dimensions: hue, value and chroma. Each may theoretically be altered without disturbing the others.

**Harmony**   The pleasing combination of tones or colors.

**Hue**   The name of a color and one of its three dimensions.

**Monochromatic**   Of one single hue; of one color. In monochromatic color schemes, the dimensions of value and chroma may vary, but only one hue is used. For example, white, pink, red and deep magenta to black is a monochromatic color scheme.

**Saturation**   Strength of color, chroma, purity, brilliance, intensity.

**Shade**   The color resulting from the addition of black to a pure hue.

**Texture**   The surface quality which can absorb or reflect light and which has different tactile senses.

**Tint**   The color resulting from the addition of white to a pure hue.

**Tone**   The color resulting from the addition of grey to a pure hue.

**Value**   The lightness or darkness of a color. For example, red and pink flowers together exhibit the same hue with different values.

**Warm Colors**   Yellow, orange and red. These colors seem to come forward.

# SOURCES
*For unusual mail order plants and supplies*

112

**Azaleas, Rhododendrons and Trees**

Carlson's Garden of Verses
Box 305-H
South Salem, NY 10590
(914) 763-5958
$2.00 (deductible with order)

Girard Nurseries
P.O. Box 428, Dept. H
Geneva, OH 44041

Henry Leuthardt
Dept. 666H
East Moriches, NY 11940

Northwoods Nursery
28696 Cramer Road
Molalla, OR 97038
(503) 651-3737

Roslyn Nursery
Dept. GS, Box 69
Roslyn, NY 11576
$2.00

**Bamboo and Ornamental Grasses**

Bamboo Sorcery
666 Wagon Road
Sebastopol, CA 95472
(707) 823-5866
Over 100 species of bamboo

Kurt Bleumel, Inc.
2740 Greene Lane
Baldwin, MD 21013
(301) 557-7229
$2.00

Greenlee Nursery
301 East Franklin Avenue
Pomona, CA 91766
(714) 629-9045

**Bulbs**

Bundles of Bulbs
112 Green Spring Valley Road
Owings Mills, MD 21117
(301) 363-1371
$1.00

Dutch Gardens
P.O. Box 200
Adelphia, NJ 07710

French's Bulb Importer
Route 100
Pittsfield, VT 05762

John D. Lyon Co.
143 Alewife Brook Parkway
Cambridge, MA 02140

McClure & Zimmerman
P.O. Box 368
Friesland, WI 53935

Charles Mueller
Rare Bulb Specialist
7091 River Rd.
New Hope, PA 18938
(215) 862-2033

John Scheepers, Inc.
Flower Bulb Specialists
RD #6, Phillipsburg Road
Middletown, NY 10940
(914) 342-3727

Alex Summerville
Gladiolus World-Wide
RR #1, Box 449H
Glassboro, NJ 08028
(609) 881-0704

Van Bourgondien Brothers
P.O. Box A
245 Farmingdale Road,
Route 109
Babylon, NY 11702

**Dahlias Specialists**

Connell's Dahlias
10216 40th Avenue East
Tacoma, WA 98446
$1.00

Swan Island Dahlias
P.O. Box 900
Canby, OR 97013
$2.00

**Garden Suppliers**

The English Garden, Inc.
652 Glenbrook Road
Stamford, CT 06906
(203) 348-3048
$6.00

Gardener's Eden
P.O. Box 7307
San Francisco, CA 94120
(415) 421-4242

Gardener's Supply
128 Intervale Road
Dept. PH029R
Burlington, VT 05401
(802) 863-1700

Kinsman Company
River Road
Dept. 925
Point Pleasant, PA 18950
(215) 297-5613

The Natural Gardening
Company
217 San Anselmo Avenue
San Anselmo, CA 94960
(415) 456-5060

Smith & Hawken
25 Corte Madera Ave.
Mill Valley, CA 94941
(415) 383-2000

Walt Nicke Company
36 McLeod Lane
P.O. Box 433
Topsfield, MA 01983

The Wood Garden
11 Fitzrandolph Street
Green Brook, NJ 08812
(201) 968-4325

**Historical Roses**

Greenmantle Nursery
3010 Ettersburg Road
Garberville, CA 95440
$3.00

Historical Roses
1657 West Jackson Street
Painesville, OH 44077

Jackson & Perkins Company
Medford, OR 97501
(503) 776-2400

Roses of Yesterday & Today
802 Brown's Valley Road
Watsonville, CA 95076
$2.00

Roseway Nurseries
123 Stenerson Road
Woodland, WA 98674
(206) 225-8244
$1.00

### Iris

Cooper's Garden
212 West County Road C
Roseville, MN 55113

Ensata Gardens
9823 East Michigan Avenue
Galesburg, MI 49053
$2.00

The Iris Pond
7311 Churchill Road
McLean, VA 22101
$1.00

Laurie's Garden
41886 McKenzie Hwy.
Springfield, OR 97478

Schreiner's Iris Gardens
3643 Quinaby Road N.E.
Salem, OR 97303
$2.00

### Lilies

North American Lily
Society, Inc.
Mrs. Dorothy Schaefer
P.O. Box 476
Waukee, IA 50263
$12.50

B & D Lilies
330 P Street
Port Townsend, WA 98368
$2.00

Borbeleta Gardens
15974 Canby Avenue
Faribault, MN 55021
$3.00

Fairyland Begonia &
Lily Garden
1100 Griffith Road
McKinleyville, CA 95521
50¢

Lee Bristol Nursery
Gaylordsville 575, CT 06755

Oregon Bulb Farms
14075 N.E. Arndt Road
Aurora, OR 97002
$2.00

Rex Bulb Farms
P.O. Box 774
Port Townsend, WA 98368
$1.00

John Scheepers, Inc.
RD #6, Phillipsburg Road
Middletown, NY 10940
$3.00

### Peonies

Caprice Farm Nursery
15425 S.W. Pleasant Hill Road
Sherwood, OR 97140
$1.00

The New Peony Farm
P.O. Box 18105
Vulcan, MI 49892
$1.00

Smirnow's Son
11 Oakwood Drive West,
Rte. 1
Huntington, NY 11743
$2.00

Gilbert Wild & Son, Inc.
1112 Joplin Street
Sarcoxie, MO 64862
$2.00

### Perennials

Appalachian Gardens
P.O. Box 82
Waynesboro, PA 17268
(717) 762-4312

Bluestone Perennials
7211 Middle Ridge Road
Madison, OH 44057

Busse Gardens
Route 2, Box 238
Cokato, MN 55321
$2.00

Carroll Gardens
P.O. Box 310
Westminster, MD 21157
$2.00

The Crownsville Nursery
P.O. Box 797
Crownsville, MD 21032
$2.00

Donaroma's Nursery
Box 2189
Edgartown, MA 02539
$3.00

Garden Place
P.O. Box 388
Mentor, OH 44061
$1.00

Heritage Gardens
1 Meadow Ridge Road
Dept. 76-1817
Shenandoah, IA 51602

Holbrook Farm & Nursery
Route 2, Box 223B
Fletcher, NC 28732
$2.00

J.L. Hudson, Seedsman
P.O. Box 1058
Redwood City, CA 94064
$1.00

Indigo Knoll Perennials
16236 Compromise Court
Mt. Airy, MD 21771
$1.00

Klem Nursery
Rte. 5, 197 Penny Road
South Barrington, IL 60010
(312) 551-3715
Including excellent peonies,
iris and daylilies

Milaeger's Gardens
4838 Douglas Avenue
Racine, WI 53402
$1.00

Park Seed Company
Cokesbury Road
Greenwood, SC 29647

Plants of the Southwest
1812 Second Street
Santa Fe, NM 87501
(505) 983-1548

Rice Creek Gardens
1315 66th Avenue NE
Minneapolis, MN 55432
$2.00

Rocknoll Nursery
9210 U.S. 50
Hillsboro, OH 45133

Sunlight Gardens
Route 1, Box 600-GS
Andersonville, TN 37705
$2.00

Surry Gardens
P.O. Box 145
Surry, ME 04684
$2.00

Thompson & Morgan
P.O. Box 1308
Jackson, NJ 08527

Andre Viette Farm & Nursery
Route 1, Box 16
Fisherville, VA 22939
$2.00

Wayside Gardens
Hodges, SC 29695
$1.00

113

White Flower Farm
Litchfield, CT 06759
$5.00

## Water Gardens

Lilypons Water Gardens
2900 Design Road
P.O. Box 10
Buckeystown, MD 21717
(301) 874-5133

Van Ness Water Gardens
2460 North Euclid
Upland, CA 91786
(714) 982-2425

Santa Barbara Water Gardens
P.O. Box 4353
Santa Barbara, CA 93103
(805) 969-5129

William Tricker, Inc.
Dept. HM
7125 Tanglewood Drive
Independence, OH 44131
(216) 524-3491
$2.00

Waterford Gardens
74 East Allendale Road
Dept H
Saddle River, NJ 07458
(201) 327-0721

## Wildflowers, Annuals and Seeds

Burpee Gardens
300 Park Ave.
Warminster, PA 18991

Eco-Gardens
P.O. Box 1227
Decatur, GA 30031
$1.00

Gardens of the Blue Ridge
P.O. Box 10
Pineola, NC 28662
$2.00

Heirloom Seeds
P.O. Box 245
Dept. H
West Elizabeth, PA 15088

Maplethorpe
11296-H Sunnyview N.E.
Salem, OR 97301-9062
45¢ stamp for catalog

Native Gardens
Box 494
Greenback, TN 37742
$1.00

Nature's Garden
Route 1, Box 488
Beaverton, OR 97007
$1.00

Niche Gardens
Route 1, Box 290
Chapel Hill, NC 27516
$3.00

Piccadilly Farm
1971 Whippoorwill Road
Bishop, GA 30621
$1.00

The Primrose Path
RD #2, Box 110
Scottdale, PA 15683

Shady Oaks Nursery
700 19th Avenue N.E.
Waseca, MN 56093
$1.00

Sunlight Gardens
Route 1, Box 600
Andersonville, TN 37705
$2.00

We-Du Nurseries
Route 5, Box 724
Marion, NC 28752
$1.00

Woodlander's, Inc.
1128 Colleton Avenue
Aiken, SC 29801
$1.50

# BIBLIOGRAPHY

Bjork, Christina, and Lena Anderson. *"Linnea in Monet's Garden."* New York: R&S Books, 1987.

Chevreul, M.E. *The Principles of Harmony and Contrast of Colors,* 1890.

Doyle, Michael E. *Color Drawing.* New York: Van Nostrand Reinhold Co., 1981.

Figes, Eva. *Light.* London: Hamish Hamilton, 1983.

Hobhouse, Penelope. *Color in Your Garden.* Boston: Little Brown and Company, 1985.

House, John. *Monet, Nature Into Art.* New Haven: Yale University Press, 1986.

Johnson, Hugh. *The Principles of Gardening.* New York: Simon & Schuster, 1979.

Joyes, Claire. *Claude Monet: Life at Giverny.* New York: The Vendome Press, 1985.

Paul, Anthony, and Yvonne Rees. *The Water Garden.* London: Penguin Books, 1986.

Pereire, Anita, and Gabrielle Van Zuylen. *Gardens of France.* New York: Harmony Books, 1983.

Perenyi, Eleanor. *Green Thoughts: A Writer in The Garden.* New York: Vintage Books, 1983.

Reader's Digest Association Ltd. *Reader's Digest Guide to Creative Gardening.* London: Reader's Digest Association Ltd., 1984.

Rewald, John. *The History of Impressionism.* New York: Museum of Modern Art, 1973.

Stone, Irving. *Depths of Glory.* New York: Doubleday & Co., 1985.

Stuckey, Charles F. *Monet: A Retrospective.* New York: Park Lane, 1985.

———. *Monet: Water Lilies.* New York: Park Lane, 1985.

Sunset Books and Sunset Magazine Editors. *Sunset Western Garden Book.* Menlo Park, Ca.: Lane Publishing Co., 1988.

Van der Kemp, Gerald. *A Visit to Giverny.* Musée Claude Monet, 1986.

Wildenstein, Daniel. *Claude Monet: Biographie et Catalogue Raisonne.* 1974-1986.

———. *Monet's Years at Giverny—Beyond Impressionism.* New York: Metropolitan Museum of Art, 1978.

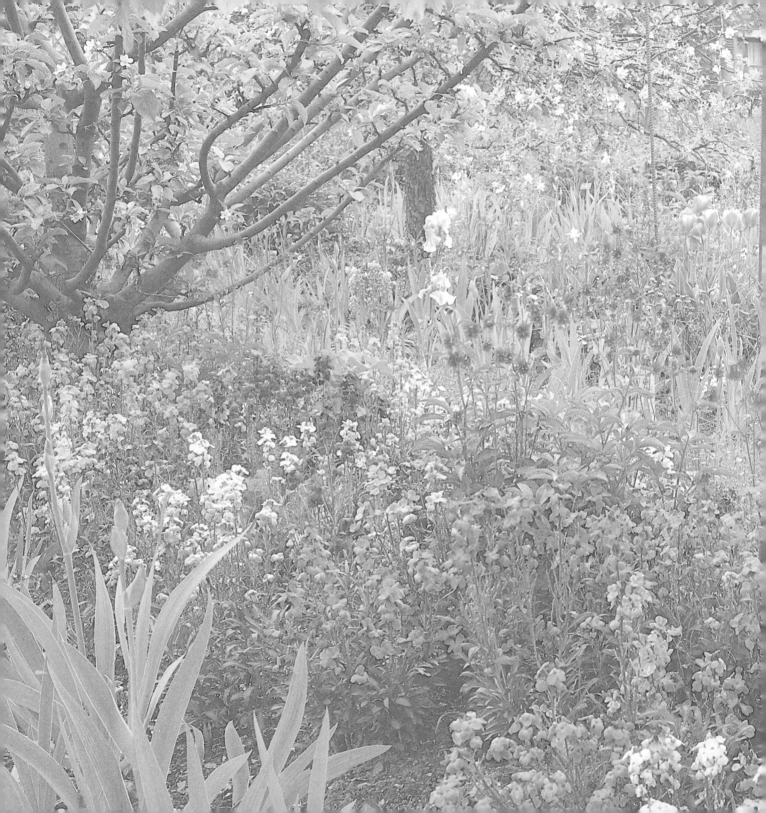